WATERCOLOUR Troubleshooter

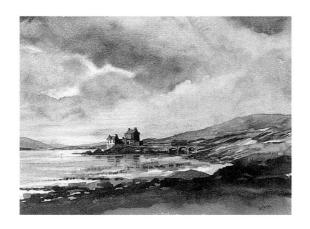

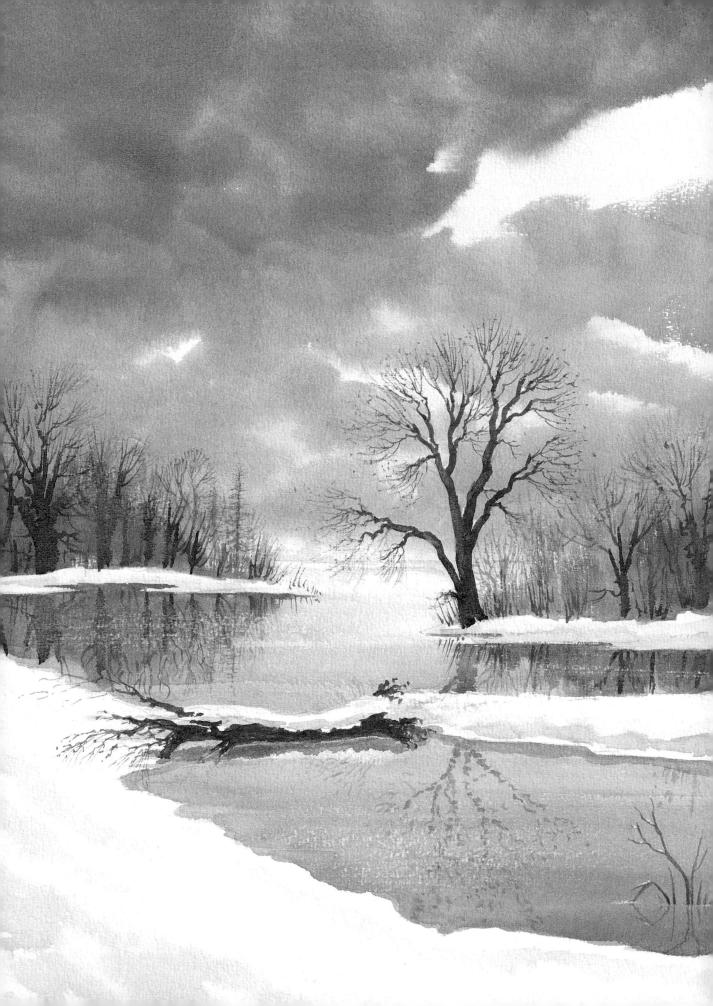

WATERCOLOUR Troubleshooter

PRACTICAL SOLUTIONS TO COMMON PAINTING PROBLEMS

DON HARRISON

First published in 1998 by HarperCollins*Publishers* 77-85 Fulham Palace Road Hammersmith London W6 8JB

The HarperCollins website address is www.fireandwater.com

 $03\ 02\ 01\ 00\ 99$ $9\ 8\ 7\ 6\ 5\ 4$

© Don Harrison, 1998

Don Harrison asserts the moral right to be identified as the author of this work

All rights reserved. No part of this publication may be reproduced, stored in a retrieval system, or transmitted, in any form or by any means, electronic, mechanical, photocopying, recording or otherwise, without the prior written permission of the publishers.

A catalogue record for this book is available from the British Library

Editor: Geraldine Christy

Designed by: Crispin Goodall Design Ltd Photographer: Nigel Cheffers-Heard

A companion video, also entitled *Watercolour Troubleshooter*, is available from Artyfacts, P.O. Box 2182, Poole, Dorset BH16 6YU

ISBN 0 00 412984 9

Set in 10/13 pt New Baskerville Colour origination by Colourscan, Singapore Printed and bound in Italy by Rotolito Lombarda SpA

Page 2:

A New Dawn

560 x 380 mm (22 x 15 in)

Contents

	Introduction	6
1	Materials	8
2	Finding and Arranging the Subject	12
3	Creating Mood and Depth	18
4	Choosing and Mixing Colours	22
5	Skies	32
6	Hills and Mountains	42
7	Trees	50
8	Water and Reflections	60
9	Features in the Landscape	70
10	Figures, Animals and Birds	84
	Finishing Touches	94
	Index	95

Introduction

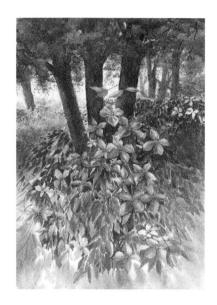

Clematis

500 x 340 mm (20 x 13½in)

It is always a pleasure to suddenly discover flowers lurking in a country hedge shaded by the trees. It is important to vary the sizes of the blooms when painting them. The light shining through the trees adds interest and atmosphere.

In many ways painting is similar to cooking. Give two people the same ingredients, equipment and recipe and ask them both to produce a culinary masterpiece, and what happens? The results will be completely different. The outcome will be affected by each person's experience, character, flair, timing and individual creativity. Painting in watercolour produces equally varied results and that is why it is so fascinating. Add the unpredictability of the medium and you have a wonderfully challenging, yet therapeutic, hobby.

Sadly, many new painters do not experience this pleasure and are tempted to give up when their pictures go wrong, so it is not surprising that at workshops and exhibitions I am asked all kinds of questions from people anxious to improve. Despite the wealth of advice now available from books, videos and television, the same problems seem to keep cropping up over and over again. It appears that what people need is a better understanding of why things go wrong and clear, simple explanations of the theories, methods and techniques needed to improve their painting skills. Above all, they need encouragement and reminding that painting should bring pleasure, not pain. Herein lies the main purpose of this book – to help long-suffering painters

Milking Time

330 x 400 mm (13 x 16 in)
Including the farmer as he opens the
gate adds interest to an otherwise
standard rural scene and allows the
viewer to imagine the cattle moving
through the gate. The large cluster of
animals is offset by the smaller ones
placed in the background and this also
gives a sense of scale.

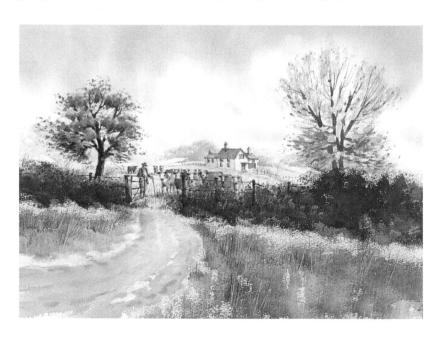

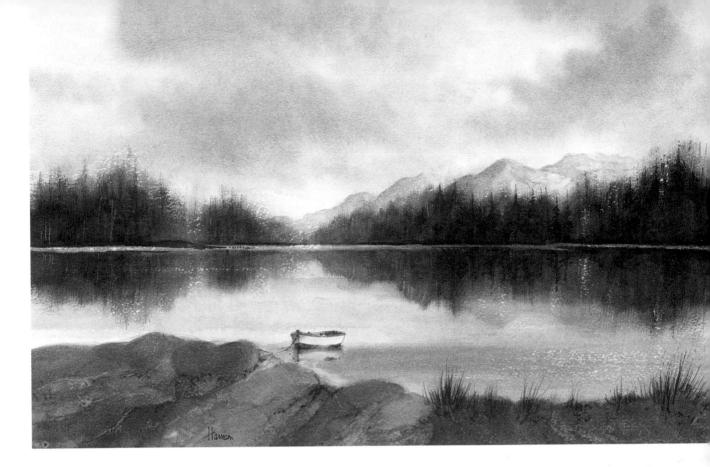

The Lake

320 x 495 mm (13 x 20 in)
Often a simple painting like this
involves careful planning. The cool
colours of the mountains suggest
distant peaks and the tree reflections
are almost a mirror image in the still
water. Adding a small empty boat gives
weight to the feeling of a vast open
space and provides a focal point.

overcome the more common problems and to enable them to achieve their true potential and enjoy their painting more.

Many people could produce more successful work with foresight and better planning. The best way to avoid problems is to adopt a planned approach that will help you to produce consistent results. Everyone is keen to start splashing paint around, but if you take time to consider carefully what you wish to achieve, then plan accordingly, you are already on the road to better painting. Make a start now by trying to prepare and plan your paintings so that you can avoid common errors and produce more satisfying results.

Surprisingly, the biggest single barrier to success in watercolour painting lies in its main ingredient – water! The use of excessive amounts of water coupled with insufficient pigment invariably leads to loss of control. Add the effects of poor brush selection and techniques, and bad timing, and it is not surprising that many amateur painters lose confidence, or even give up completely. This is a tragedy, because for me painting is one of life's great pleasures and I would like others to enjoy the same satisfaction. So I hope this book will help to bring this about.

Materials

Generally speaking, buy wisely – preferably the best materials, paints and brushes that you can afford. This will get you off to a good start.

Paper

Good quality rag paper is a joy to use and is the wise choice. 400 gsm (200 lb) or heavier means you can avoid having to stretch the paper and you can also use both sides if you need to, which effectively halves the price. Unstretched 300 gsm (140 lb) watercolour paper may be suitable for small paintings, but not for large ones. Avoid thin cartridge paper and other papers that are really designed for pencil work.

Smooth watercolour paper is fine for detailed studies, but Rough or Not is better for general work. Find one that suits your subject matter and style of painting, not one that your friend or teacher happens to prefer. Always use the same type of paper for practising on or for testing the colours so that you can judge against the same characteristics.

Glasspaper

Use the doubled-over edge to produce a fine line on dried paint, or carefully use it flat to the paper to lift out highlights.

25 mm (1 in) flat brush

Buy one that retains its shape and does not leave gaps in the bristles as soon as you dip it in water.

Squirrel brush

The odd shape makes it ideal for painting subjects that require both thick and thin lines.

50 mm (2 in) hake brush

Inexpensive goat hair brush. Ideal for large washes, fields, hedges and foliage. Squeeze out excess water before picking up paint.

Brushes

Buy the best brushes you can afford, especially where round sable brushes are concerned, because they retain their springiness for far longer. A brush should hold its shape well when dipped into clean water and should not splay out so that the hairs separate. If a brush does not regain its shape consistently do not use it.

Paints and palettes

I use tube paints in preference to pans because they suit my method of mixing. I feel that pans encourage people to be frugal with the paint, resulting in watery paint mixtures and leading on to all manner of problems. Some students' quality paints lack sufficient pigment, so buy artists' quality paints that will help to give your work more body.

As far as a palette is concerned, I use a simple round white plastic tray because it allows plenty of space to mix the colours. See Chapter 4 'Choosing and Mixing Colours' for more detailed help.

Painting knife

Normally associated with oil painting, these knives are useful for scraping out almost dry paint to make light marks and for moving paint around to form light and dark patches.

Scalpel

The sharp point can be used to pick out white highlights.

Sizes 5 and 8 medium round sable brushes

For fine detail or general work.

Size1 sable rigger brush

Inexpensive and invaluable. The long hairs produce very fine lines ideal for painting thin twigs or branches.

Bristle brushes

Stiff bristle brushes are more often associated with oils and acrylics, but they are particularly good for teasing out paint to lighten dark areas.

Watercolour Paper – Avoiding Cockling

I always use good-quality paper and tape it to my board all around the edge, but it still cockles when dampened. I thought it would remain flat if taped in this way. So, why is this?

This problem occurs when thin watercolour paper is taped straight onto a board without soaking it in water first. As soon as the paper is dampened or a heavy wash applied it cockles.

Restrained by the tape it cannot stretch, resulting in a corrugated sheet of wet paper with pools of water in places.

The weight of the paper is the problem here, not the quality. Apart from when used for small paintings, 200 gsm (90 lb) or 300 gsm (140 lb) paper is prone to cockling when soaked

repeatedly, so if you do not wish to bother with stretching, buy thicker paper – 400 gsm (200 lb) or over.

It is easier to use a backing board roughly the size of your paper, with spring clips to hold the paper to the board at each corner. If any bulging of the paper should still occur while you are painting, release the pressure on the clips and pull the paper tight.

If you use thinner paper, stretch it properly. Soak it for a minute or two, tape it to a slightly larger board using gummed tape and leave flat to dry out.

Sailing

350 x 490 mm (14 x 19½ in) When painting a wetin-wet scene with a number of overlaid washes, even heavy paper will tend to bulge a little in places. Using clips to restrain the paper allows you to release them at intervals and pull the paper taut. This is much simpler and quicker than prestretching the paper.

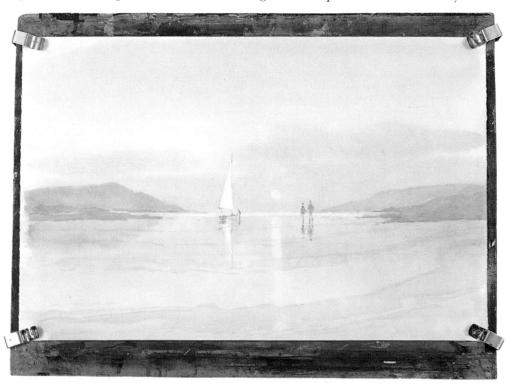

Selecting the Right Brush for the Job

Once I have drawn up the picture, I find it difficult to decide which brushes to use for the particular subject and the various elements that make up the painting. How do I select the right brush?

Select suitable brushes for the job in hand. In this coastal scene I am using the rigger to paint the thin vertical line of the distant mast - the ideal brush for fine lines. I used a 25 mm (1 in) flat brush to achieve a loose treatment for the buildings in the early stages and for bold colours on the hull of the red boat, using vertical brush strokes For the rocks I used a large round brush and curved strokes, using light colours at first overlaid with stronger tones for shading.

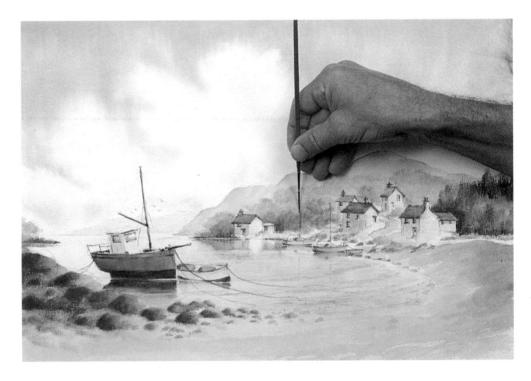

The best advice for selecting which brush to use is to choose the most suitable brush for the job in hand. Once you are accustomed to the various strokes that are possible with each brush, the choice should

Use larger brushes in the early stages of a painting when you need to dampen the paper and apply large washes. Later in the painting medium size brushes are likely to be most suitable. Take up small brushes only in the closing stages to add detail.

become automatic.

As far as individual elements are concerned, always consider the shape of the object you are painting and its general bulk. Choosing a particular shape brush to suit the object will help you to paint it more easily. If you are painting a rounded object, the chances are that a round brush will fit the bill. If you need large, squarish shapes use a flat brush. If you want to achieve a loose painting style, get into the habit of simplifying elements at the drawing stage, then use the largest brush you can handle; this will prevent you from putting in too much detail.

Finding and Arranging the Subject

There is a wealth of material available to paint – even for people who are unable to travel. All you need is a little imagination. Try to avoid painting the obvious – poor choice of subject matter will get you off on the wrong foot and kill your enthusiasm.

Using reference material

You can find a massive range of reference material in your own home or garden or when out and about. Search for inspiration in newspapers, photo albums, books, travel guides, catalogues and videos. Potential subjects abound in town centres, gardens, zoos, historical buildings, art galleries and golf courses as well as in the country, at the seaside and by the river.

When you are out driving or walking, keep a camera or sketchbook handy, because even if access is difficult or time is short, a quick sketch or reference photo is usually all you need to remind you of the important features in a scene. Seasonal variations on existing work are another interesting possibility.

Selecting the elements

As an artist, you have the advantage of being able to improve on what you see, so avoid the temptation to include every detail. Many painters, whether they are on

A small, basic line drawing will help you to simplify the composition and arrange the main elements in the most effective way. This need not be a work of art – just a guide to show the position of the main land masses and any other important features. It is far better to clarify your thoughts at this stage than to change tack in the middle of a painting.

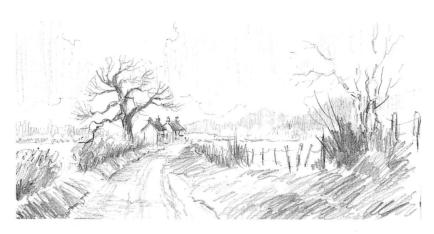

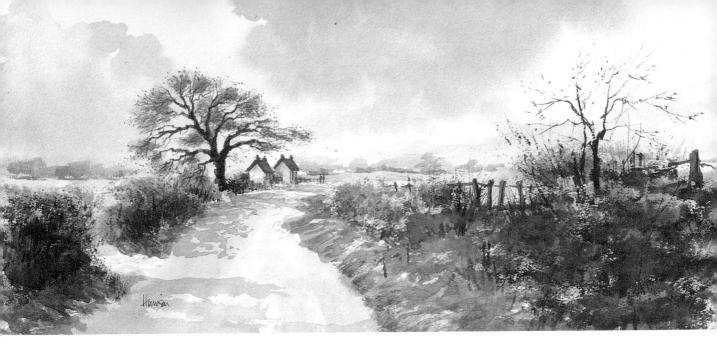

Somerset Lane

260 x 510 mm (10½x 20½ in)
In this country scene in Somerset I
have retained the essential feel of the
lane in which the large tree dominates
the composition. The panoramic
format emphasizes the open nature of
the area, enhanced by adding a
brooding sky. Inserting a young sapling
on the wide bank on the right provides
a useful counterbalance to the bulk of
the tree and the cottages, and
discourages the viewer's eye from
wandering out of the frame.

location or working from reference pictures, study a scene with the sole object of reproducing it as accurately as possible. Reality is seldom perfect, however, so striving for a true photographic likeness usually results in a rather stilted, picture postcard effect that lacks atmosphere and spontaneity. Teaching yourself to be selective when looking at potential subjects is all part of the picture-making process, so learn to include only what is essential to get your message across.

Planning the composition

Planning a painting should be a two-part process that involves a simple line drawing to arrange the various components pleasingly, then a monochrome value sketch to establish tonal contrast. These sketches can be used as guides to help you produce a trouble-free finished work.

Porlock Weir

320 x 450 mm (13 x 18 in)
This well-known English tourist haunt is a favourite with visitors and painters alike. I took the trouble to walk well away from the main cluster of buildings to find an interesting low-level viewpoint and rearranged the position of the boats to enhance the composition. Although the tide was almost out I painted a higher water level to add to the effect.

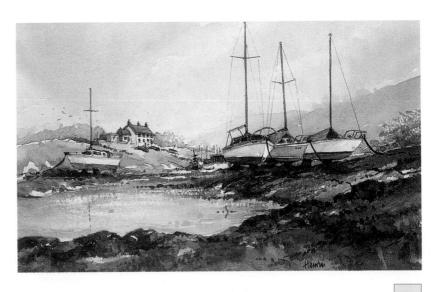

The Importance of Good Design

I love to paint but I am not very good at drawing and have trouble composing the subject. My art teacher insists that the drawing stage is important, so how can I get round this?

> Many teachers pay far too much attention to good draughtsmanship and, sadly, this is guaranteed to put off many new painters. While good drawing skills are a great help, they are not vital for you to be able to enjoy painting. By making a simple planning sketch based on good design principles and following logical rules of composition, at least the general construction of your painting will be sound, making a good starting point. For the finished painting, keep your initial drawing as simple as possible and

use the brush to put in any detail at the painting stage. This helps to avoid a laborious, paint-by-numbers effect and the result should be much looser. Try to 'draw' with the brush, suggesting the various elements in your painting with bold, simple strokes. This way of working can be far more expressive and allows you to enjoy the pleasures of painting despite your lack of expertise with a pencil.

Good composition relies mostly on common sense. Each time you position an item, think about its relationship to the other elements and judge for

The Lone **Fisherman**

340 x 240 mm (13½ x 9½ in) I used a soft pencil for the planning sketch for this painting. The solitary fisherman is the focal point and has been positioned a different distance from each side of the frame. The vertical grouping of elements formed by the fisherman and tree, together with their reflections, are balanced by the horizontal strip of land. The tall cluster of foreground grasses counterbalances the elements positioned

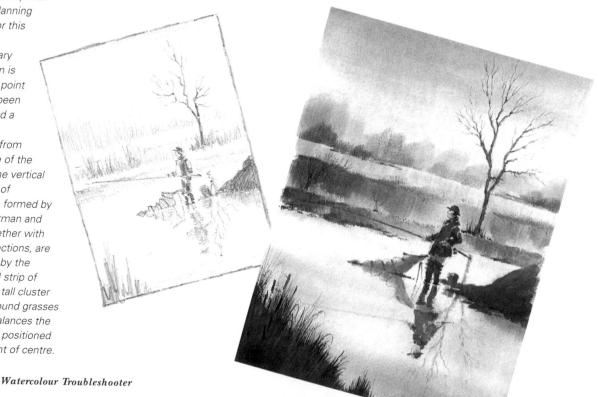

to the right of centre.

This planning sketch was completed using red ballpoint pen. The low horizon emphasizes a dramatic sky which is nicely

balanced by the two darker areas of land.

Variety is important here. Note that the three areas of land are of varying shape and size – one large, one medium and one small, which is an ideal arrangement.

A blue graphic pen was used for this quick sketch.

Make sure that any directional lines lead to the focal point and not out of the frame. This sketch was drawn in black felt-tip pen and stresses the

sweeping track, hedges and fence. Even the clouds lead the viewer's eye to the focal point.

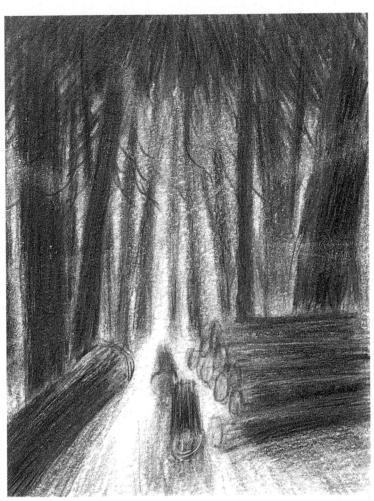

yourself as to its suitability in terms of size, shape and texture. Think 'variety' – if something does not look right, then change it or leave it out.

Here are a few key points to bear in mind. Position the horizon low or high (but not central) to emphasize either the sky or foreground as required. Outline the main land masses, avoiding equal-sized shapes and spaces. Position the focal point an unequal distance from each side of the frame. Make it sufficiently large and interesting to grab the viewer's attention.

Ensure that any directional lines or shapes lead the eye to the focal point and not out of the picture. Repetition of shapes or lines creates harmony, but make sure you vary the dimensions. Balance clusters of horizontal lines with the odd vertical one or vice versa to retain visual interest.

I used coloured pencils for this quick sketch and they are effective in planning the dominant upright trees. Note the variation in thickness of the trunks. Additional variety is provided by the horizontal cluster of cut logs. The single large log in the foreground is positioned at an angle to create additional impact and leads the eye into the frame.

Allowing Your Subject Room to Breathe

I start my painting by carefully drawing the main subject, but I always seem to run out of space. If I do a rough sketch first, why does the finished version never look the same?

Transferring a small drawing to a larger piece of paper need not be a problem. Simply lay the small drawing over one corner of your large sheet and extend the base line (A) and nearest side (B) by drawing horizontal and vertical lines from the corner. Then, from the same corner, extend a diagonal line (C) through the diagonally opposite corner and extend this line until it reaches the required distance. From this point draw a vertical (D) and horizontal line (E) to meet up with the previously drawn base and side lines.

I left plenty of space around my drawing and even though I exceeded the guidelines when painting the scene I was still left with further room for manoeuvre. Here the composition could be improved if some of the right-hand side of the picture is masked.

A

Always use a small planning sketch and position the horizon line first, before outlining the

main land masses. Then place the focal point in a spot with plenty of space around it. Give your main subject room to breathe and avoid placing trees, buildings or other large features too near the edge of the painting.

Using the planning sketch as a guide, transfer the drawing in the same sequence and same proportions to your watercolour paper. Allow plenty of space around the image area, indicating this with a light pencil outline, or better still, leave an imaginary border, stopping your drawing well short of the edge of the paper. If you paint beyond the image area, the extra space around the edge allows flexibility and room to manoeuvre. It also allows you scope to mask off a selected part of the finished picture to give the best composition. Even the best planned painting can sometimes be improved by masking.

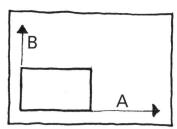

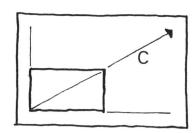

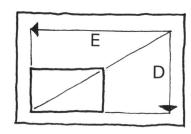

Directing the Viewer's Eye – the Focal Point

I enjoy painting landscapes, but many of my finished pictures seem to have something lacking. Yet, in most cases, the original scenes were really interesting. Am I missing something here?

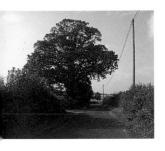

Summer Walk

340 x 480 mm (13½ x 19 in)
The country lane in this photograph makes an ideal subject for a painting. The large tree dominating the skyline tends to be overpowering, so the addition of another feature may well enhance the composition.

Adding figures to the scene provides an ideal focal point. As well as providing more balance and interest to a fairly bland view the figures supply a sense of scale and prevent the eye from wandering around the picture.

A huge expanse of sky or open country or even a winding country lane can often stop us in our tracks.

Yet what appears to be a stunning view can appear somewhat underwhelming when seen as a photograph or painting. In reproducing the scene as a painting, frequently what is lacking is a centre of interest or focal point to attract the eye of the viewer. This is even more important in a broad expanse of countryside, otherwise the painting will lack impact and the viewer's eye will not know where to come to rest.

The focal point should be the reason for the painting and the rest of the

picture of secondary importance. Think why you started the painting in the first place – what inspired you – because you need to be conveying these same feelings to the viewer or reminding yourself of an unforgettable experience. In an open view it may just be a huge cloud formation or the light shining on a distant rooftop. If you have a good reason for painting a scene, it has more chance of being successful. If you love a scene but there is no focal point, make one up. Often, adding figures, a boat, a building or a tree may be the simple answer.

Creating Mood and Depth

Light Through Clouds

330 x 460 mm (13 x 18 in)
I added the small boat and the row of stones in the foreground and emphasized the ripples of light dancing on the sea in the distance to enhance this dramatic scene photographed by a friend in Scotland. To produce the rays of light shining through the clouds, I waited for the paint to dry completely, then gently used a soft eraser to rub out the rays without damaging the paper, making sure they all emanated from the same source.

Always decide a position for the sun behind one of the larger cloud masses and let the sun's rays appear from this one spot. Do not overdo this or the effect will look unnatural. As an artist, you should view a scene and consider what attracts you to it – whether it is the light, the atmosphere, the colours, or bold dramatic shapes. This initial impression should be the main focus of your efforts. Your aim should be to re-create the magic – to make a painting that will convey the same mood or feeling to the viewer.

Describing the scene

Think how you would describe a scene in your own words. Decide which aspects you would stress, then translate your thoughts or words into pictorial form, if necessary emphasizing certain points to get your message across. In a scene with breathtaking views of distant mountain peaks with mist rolling in through the valley, for instance, those huge peaks will dominate your impressions. So overlook the trivial details such as the

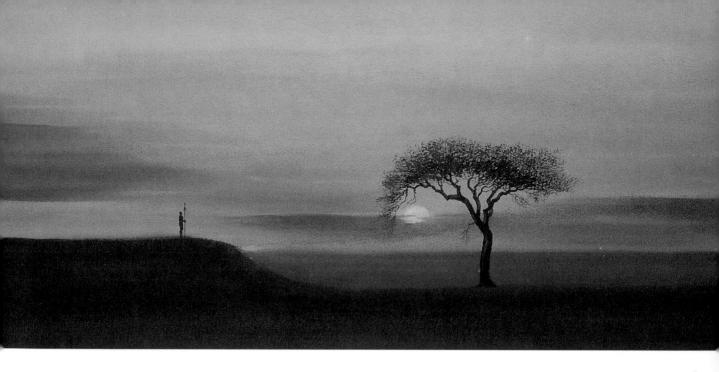

Kenyan Vigil

360 x 740 mm (14 x 30 in)
This painting was inspired by a
wonderful photograph of a lone tree
from which appeared to hang a typical
African setting sun. For more drama I
changed the upright format of the
photo to a panoramic vista and, for
balance, inserted the local villager
surveying the scene. I think these
changes add to the feeling of space
and isolation. It is essential in painting
these graduated skies to use broad
horizontal strokes with a large brush,
so all the emphasis is on the horizontal.

bus stop at the side of the road and stress the elements that stimulate.

So what makes a good painting?

Art is a very personal matter and individual tastes vary, but when we view a painting, a number of factors determine whether we react favourably or feel uneasy. A well-executed painting that pleases you may do so not just because of technical merit, but because of a number of reasons that are not immediately apparent.

The next time you visit an exhibition of paintings, try wandering around with your eyes half closed. Two things will probably happen. The chances are you will bump into some very interesting people but, more important, the effect of the colours will be reduced and you will probably see each painting as a series of monochrome tonal shapes. Some of these will be striking, and others uninspiring. The difference relies on the successful juxtaposition of light and dark areas and the variation of large and small shapes and the degree of contrast between them, creating the illusion of a threedimensional image on a flat expanse of paper. When it comes to colour, these value differences are more critical and choosing colours to re-create the changing values requires thought and planning. Attending to these essentials is crucial to achieve success at painting and conveying something of value to the viewer.

Suggesting Depth Through Tonal Variation

However interesting and exciting the subject matter, my paintings always look pale and insipid, seeming to lack depth. How can I make them appear more realistic and give them more impact?

> Your paintings lack depth and impact because there is too little tonal contrast. The first step to solving this problem is to plan your paintings better, by turning your small compositional planning sketches into tonal value studies using a single colour. This will help you to be more conscious of the differences in tone between the different areas in your subject. Painting the distant areas in pale tones

and the nearer parts in dark tones will also help. Remember where possible to arrange light against dark and dark against light. If you can successfully arrange contrasting tones to give a realistic impression using just one colour, it should be easier to achieve a similar effect when you are using the full spectrum. In the final painting cooler, paler colours will suggest distant areas and warmer, stronger colours will help to bring the foreground forward.

Another problem may be that your paint mix is too insipid. With weak watery paint it is virtually impossible to achieve any strong contrast.

Ultramarine Blue was used for this tonal sketch based loosely on a local scene. Keeping the distant peaks and tree lines pale in tone adds to the feeling of depth, which is accentuated by the strong tones in the foreground. Note the grouping of the boats - one large, and two small ones overlapping. This makes a pleasing combination that is balanced by the two walking figures.

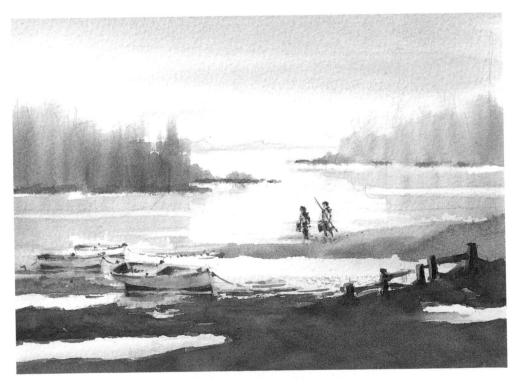

Using the Value Sketch as a Guide to Colour

I seem to have no trouble in painting a tonal sketch in one colour, but when it comes to the finished painting I cannot get the same depth and variation. Why do I find it so difficult?

The Estuary

360 x 480 mm $(14 \times 19 \text{ in})$ I used my value sketch as a guide here and made sure that the distant trees and headlands were not too strong in tone. The strong colours in the foreground and the dark figures almost in silhouette help to give the illusion of depth. The painting was mostly done using Raw Sienna, Cobalt Blue and French Vermilion with a touch of Burnt Sienna and Ultramarine Blue added to increase the strength of the darker foreground colours. A palette knife was used to push wet paint around to produce light and dark accents in the foreground.

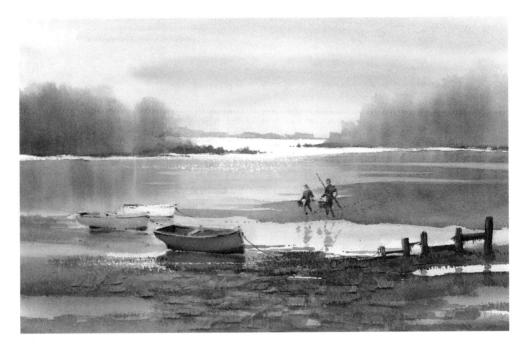

and one rather obvious reason is that many students seem to ignore their tonal sketch completely when it comes to the real painting. It is essential to try and capture the same feeling of contrast and depth in the finished work, so keep the value sketch in view and refer to it while working on the finished painting. Your small sketch should be your own improved version of reality. Regard it as your blueprint

This is a common problem

Although at first it is quite difficult to convert monochrome tones into

for producing a better finished result.

colours of the same value, this is something that comes with practice. It is essential to start by keeping any underwash very light and avoiding strong, warm colours in the distant areas, even if there are similar colours in the real scene. Particularly in the early stages, you may find it helpful to test each colour on a piece of scrap paper and compare it with the same area in the tonal sketch.

You should bear in mind that it is always easy to darken a colour in the later stages of a painting, but much harder to lighten it without making it look overworked.

Choosing and Mixing Colours

The massive range of colours available can be very confusing. So, when considering a basic starter palette, it is wise to start with the primary colours – these are the bright reds, yellows and blues that cannot be mixed from other colours.

Warm and cool colours

Choosing a cool and a warm version of each hue offers a large degree of flexibility, enabling you to mix a huge number of colours that have a warm or cool appearance. It is generally accepted that cool colours have a leaning towards blue or green and warm ones have a red or orange bias. In most cases this colour bias is fairly obvious to see, so selecting two of each of the primaries is easily accomplished and will set you on the right road. Additional colours can be added as you require them. Manufacturers often use different names for similar colours, so in the following selection I have listed some alternatives.

Farmhouse at Ripley

345 x 530 mm (14 x 21 in)
For this autumnal scene I used hints of red in places to warm the predominantly yellow tones. An overall underwash of Raw Sienna gave a good base to the painting. The dark hedge creates contrast and helps to accentuate the warm feeling in the mid distance. I have used colours from the warm end of the colour spectrum throughout the painting.

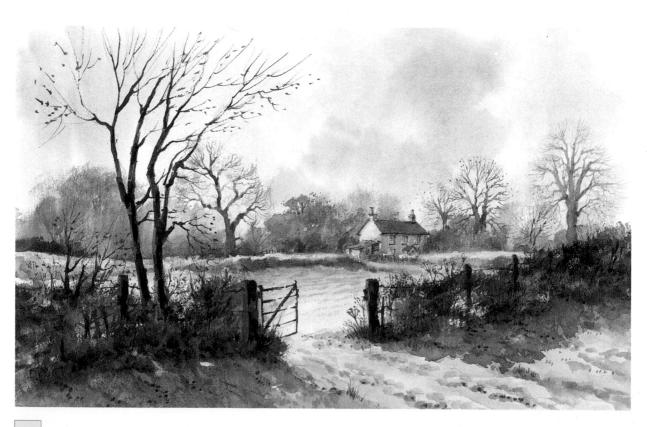

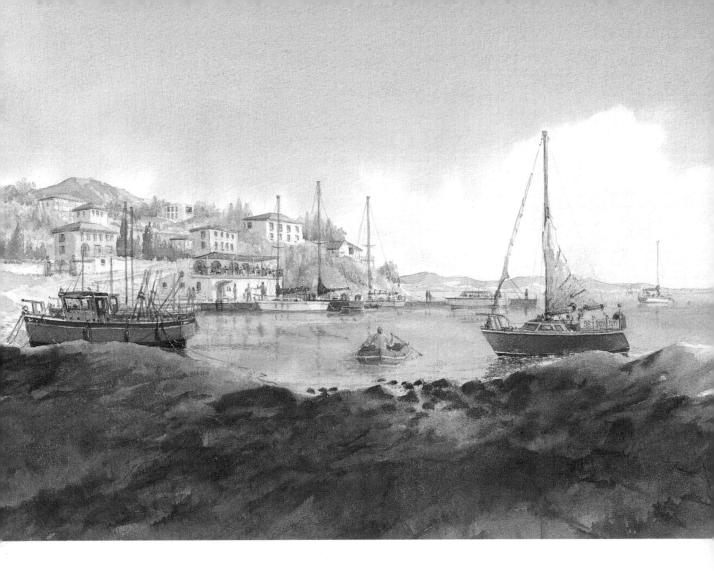

Entering Harbour

350 x 490 mm (14 x 19½in)
Here, the choice of colours suits the sunny location. Using the white of the paper to suggest the clouds makes them look fresh and bright and a touch of Viridian on the sea gives it an inviting appearance. The greens have been painted with Cobalt Blue, Lemon Yellow and Cadmium Yellow and set off the whitewashed buildings in the background. Shadows are painted with pale violet, which contrasts well with the warm surroundings.

A basic palette

The primaries I mostly use are Alizarin Crimson or Deep Madder (cool), Cadmium Red or French Vermilion (warm), Lemon Yellow (cool), Cadmium Yellow (warm), Ultramarine Blue (warm) and Cerulean Blue (cool). Other commonly used colours are Raw Sienna (this could replace Cadmium Yellow if you wish to economize), Cobalt Blue (a pleasant sky blue that is not particularly warm or cool), Burnt Umber (a strong, cool dark brown) and Burnt Sienna (which is similar to Light Red). Both Burnt Umber and Burnt Sienna make very good dark greys close to black when mixed with Ultramarine Blue.

The only ready-made green I sometimes use is Viridian, which is ideal for producing the lovely bluegreen transparent colours you sometimes find in the sea. Used straight from the tube it is a rather strident colour, so I usually blend in a touch of Ultramarine or Cobalt Blue to give it a more subtle appearance.

Arranging Colours to Reflect the Colour Wheel

After I have been painting for a while, my palette gets really messy and, as a result, I have difficulty remembering where the colours are and identifying them. Is there a solution?

> This problem usually results from using a traditional type of palette with lots of tiny pans arranged side by side. Colours start merging together and it is difficult to pick up a large brushload without touching one of the other pans. My solution is simple. I use a round white plastic tray as a palette, which allows me to keep more

> > space between the colours.

arrange the colours in the same spot on the tray, loosely matching their position on the colour wheel, so it is easy to locate them without having to check each time.

This arrangement allows you to pull the colours across the centre area of the palette in bands and overlap them as required, providing a selection of varied colour mixes to pick from. If the centre of the tray becomes messy, simply clean it with a dampened piece of kitchen roll. If at some stage the blobs of paint become muddied, use a large dampened brush to wash the muddy colour off - I usually do this over a sink using a household paintbrush.

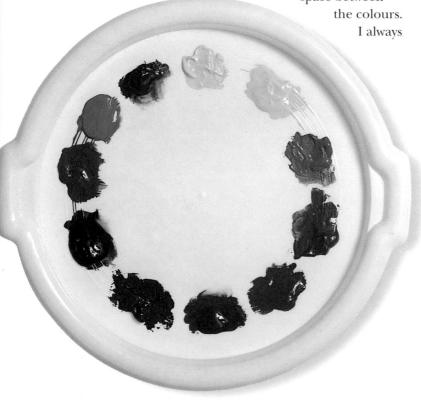

A simple tea tray makes a splendid palette, with a large mixing area in the centre. I always keep my colours in the same position to roughly match the colour wheel. The warm colours are

arranged on one side of the palette and the cool colours on the other. A cool and warm version of each primary (reds, yellows and blues) are spaced equidistantly around the perimeter for ease of mixing.

Mixing the Right Hue

I have read many books on colour mixing and they suggest it is possible to mix almost any colour, but I find the subject confusing. How can I learn to mix a particular colour that I require?

Even a modest selection of colours can be used to give a reasonable match. My method involves mixing two primary colours together, then adjusting the resulting mixture by adding a touch of the third primary.

Mixing two primaries creates a

Mixing two primaries creates a secondary colour and the third primary is always the complementary colour of the secondary colour you have mixed. For example, blue and yellow mix together to make green and the third primary, red, is the complementary colour of green. Adding the complementary colour to the secondary neutralizes it, making it less vibrant.

How does this help your mixing problem? Say you want to mix a mellow green. First, mix the two primaries that

will produce a colour closest to the one you want. For example, Ultramarine Blue and Cadmium Yellow will produce a strong green. If you add a touch of the third primary, Cadmium Red, you will neutralize the green and give it a more mellow appearance. Similarly, to achieve a brownish orange – mix red and yellow to make orange – add a touch of blue to dull it down.

In each case a tiny amount of the third primary is all that is needed to tone down the brightness. If you add too much and make the mixture too drab, add more of the original two primaries to reduce the effect. For a paler tint, pull out a little of the mixture and add water.

In the three examples of colour mixing shown here I have mixed two primaries together to produce a vibrant secondary colour. In each instance I then added a tiny amount of the third primary to tone down the brightness.

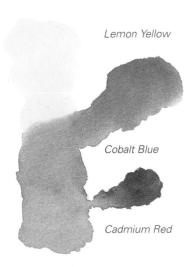

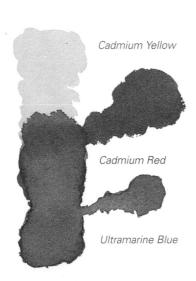

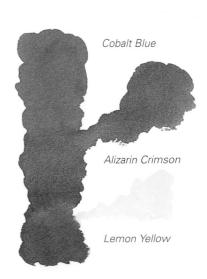

Choosing Colours to Suit the Subject

I know the effect I am trying to achieve – such as the coldness of a snow scene or the warmth of an autumn day, but I cannot decide which colours will give me the best result. Can you help?

The Lake in Winter 325 x 520 mm $(13 \times 21 \text{ in})$ Ultramarine Blue, Alizarin Crimson and Burnt Umber are the main ingredients in this cold wintry scene. The trees and their reflections were painted wet-in-wet to start with and then wet-on-dry to give a mixture of hard and soft shapes. The choice of colours has produced the effect that I required.

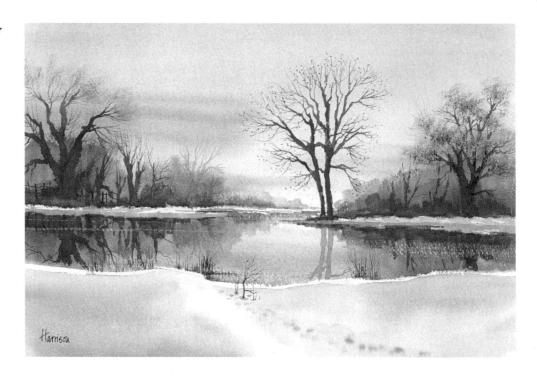

Consider the painting you are about to start and choose the colours that seem most appropriate.

Some people make up shade cards to

assist them in this and although these can be useful reminders of what is needed to produce a particular hue, there is not always time in the middle of a painting to start looking for a suitable reference. It is far better to work out which colours will be needed before you start and know that you will be able to mix the correct hues on the palette quickly and easily.

If it is a winter scene needing mostly cool colours concentrate on blues, pale greens, pale yellows and violet colours. You may wish to convey the effect of crisp cold air, ice, snow and a still atmosphere. If the scene contains water, this can be painted at the same time as the sky and often these areas will demand neutral tones painted as graduated washes. For example, a mix of cool colours, say Ultramarine Blue and Alizarin Crimson, will produce a bold violet that can be toned down with a touch of yellow (its complementary colour). This can be painted dark to

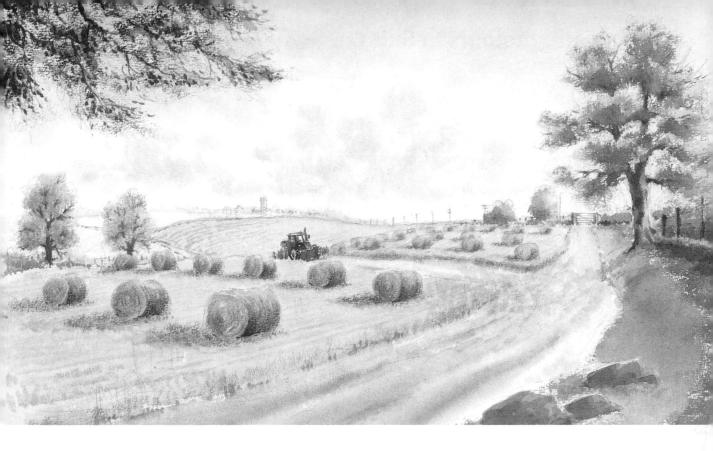

Harvest Time

360 x 500 mm (14 x 20 in) Warm colours predominate in this typical country scene. The rows of bales stand out in sharp relief as the sun goes down. The shading on the bales and the stubble was painted using Raw Sienna with a touch of French Vermilion and Ultramarine Blue. The blue of the tractor and pale green distant fields provide a cool contrast to the warm colours of the corn and stubble.

light down to the horizon, ending in a crisp edge to suggest the snow-covered distance. Leave an unpainted gap and repeat the wash, this time light to dark (because the water reflects the sky), and you have in place the background colours for the sky and water, leaving the white of the paper for the snow. Trees and their reflections can be painted using the same cool colours with the addition of Burnt Umber, which mixes with blue to give a neutral grey. Snow can be given form by washing in shades of blue and grey wetin-wet to suggest the undulations.

For sunny summer or autumn scenes choose a warmer range of colours with a leaning towards orange and red. Introduce yellows (Lemon and Cadmium), oranges (Cadmium Yellow plus Cadmium Red), warm browns (Burnt Sienna) and reds (Cadmium Red). Simply by using warm or cool colours from the appropriate side of the colour wheel you can capture the effect you need, but practise blending them on scrap paper before starting a finished work.

UNDERPAINTING AND OVERPAINTING

One way to harmonize the colours in your painting is to apply an underwash of a light toned colour over the paper before starting to apply the chosen colours. This will shine through the subsequent applications of colour and add unity to your painting. A pale combination of Raw Sienna and Lemon Yellow is ideal. It should be applied wet-in-wet over the initial drawing, making sure there are no hard edges that may cause problems later. For variation, leave a few really light areas unpainted. Allow the underwash to dry completely before proceeding with the finished painting.

To add unity to a finished painting carefully damp all over with clean water using a large brush, taking care not to disturb the existing layers of paint. Allow the water to soak in and gently overpaint suitable areas with warm or cool colours as required.

Avoiding Muddy Colours on the Palette

When I watch professional artists they seem to mix lots of colours together on the palette and produce clean colours. When I try this, my colours go muddy. What goes wrong?

Summer Day

350 x 465 mm (14x 18½ in) It is essential to retain fresh, lively colours in a holidav scene like this, so it helps to avoid overmixing on the palette. The strong directional shadows add to the effect of bright sunshine and the subdued reflected light on the building to the right increases this feeling.

This is probably because you are mixing lots of runny colours into each other and stirring them as if you are making soup. The more you stir, the darker and dirtier the mixture becomes. As you probably know, when you mix three primaries together in equal amounts, the result is a dark grey and by mixing many colours together it is all too easy to produce a similar effect accidentally.

Start by mixing the two most important colours together and you will find that this creates no problem. In fact, where possible, try to achieve the colour you need by mixing just two colours. Often, however, the only way to vary this mixture to achieve the hue

Pulling bands of strong colour across the centre of my palette allows me to select a variety of hues. As the colours do not merge completely as they would in a conventional palette they retain their freshness and clarity.

you need is by adding more colours and this is usually where the mixture starts to go muddy. The solution is to add only very tiny quantities of these other colours. In this way the main colour mix will remain reasonably fresh and the additional touches of colour will simply move the colour balance in the appropriate direction without muddying the mixture.

It is essential that the mixture should not be too weak and watery, otherwise it is difficult to prevent all the colours from running together in the mixing area. Aim for a creamy consistency of

Autumn Hedgerow 465 x 350 mm (18½ x 14 in) Close-up studies can be very rewarding and the hedgerow in our garden offers a multitude of painting opportunities. Here, the colour in the foliage has been played down to make the main subjects spring out at the viewer. Placing complementary colours together, such as red and green as in this painting, usually makes them stand out rather well – a

ploy worth cultivating.

paint, using just a little water, and pull the colours across the palette in overlapping bands. Then, each colour mixes with the other colours to a certain degree, but they are not completely blended together. This way you can select from different areas of the palette and there will be a wide range of different tones to choose from. If you clean the mixing area frequently the colours should stay fresh, but if you continue mixing on top of previously

mixed colours the likely result will be more mud.

Often, you may have a large patch of colour in the mixing area and you need a small quantity of a slightly different shade. Instead of changing all the colour, pull a little to one side and adjust that, leaving the rest of the colour intact for later use.

Avoiding the Problem of Excess Water

Whenever I mix a colour, the paint never seems to be the right consistency, the colours are either too light or too dark and the paint goes all over the place. How can I gain more control?

The water content is the problem here. Many artists are far too liberal in their use of water, which can be a major cause of anguish, because their paint mixture becomes too pale and wishy-washy. This is especially true of the frugal types who use only a tiny spot of paint on the brush instead of loading it properly.

It is essential to use just enough water, not too much, and you need to adopt a sound routine to achieve consistent results. When I first use a brush I immerse it completely in water, then wipe it on the side of the water pot to remove the drips or dab it on a piece of kitchen roll to soak up excess moisture. If it is a big brush I do both. I avoid taking the brush straight from the water to the paint or the paper because the bristles contain too much moisture to retain control. How often do you see a leisure painter do this? – the water forms a great pool on the paper, which is then furiously dabbed with a tissue. Calamity!

The only time I immerse the brush completely, once I have started painting, is to wash it out when changing colours. Once painting is underway I dip only part of the bristles into the water and ensure they are damp rather than dripping wet. If you use just sufficient water to mix the paint to a creamy consistency it is less likely to

As I remove the brush from the water pot I tap it on the rim to shake off any drops of water.

Right: Before taking the brush to the palette I dab it on a piece of kitchen roll to remove excess moisture.

Far right: A creamy blend of colour is much easier to control than an insipid watery mixture.

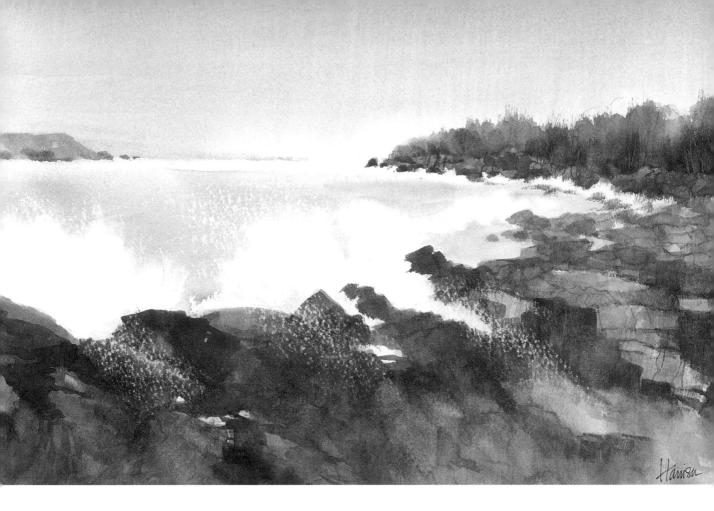

run. The strength of colour is then easy to control by adding a little more water or a little more paint to arrive at the required tonal value.

When working wet-in-wet, make sure both the brush and the paper are damp, not dripping with water. Provided your mixture of paint is strong and creamy, not weak and too watery, you will have more control over how the paint spreads on the surface of the paper.

Using a round plastic tray to mix your paint provides an easy way of blending colours together without the risk of using excess water. You need only sufficient water in the centre part of the tray to blend the colours. If you add too much water it will simply run into the sides of the tray, so this method will encourage you to make stronger, creamier blends of colour that are easier to control.

PERFECT TIMING

Timing is so important in watercolour painting and most people find it difficult to work out the magic moment when their paper is suitably receptive to paint. The right time is when the high gloss has just gone off but the paper is still damp with a slight surface sheen. Hold your painting up to a light source to check any shine on the surface or study it from the side. This may be uncomfortable for some people, so you can always use what I call a 'gloss detector'; this is simply a tilted compact or shaving mirror positioned so that you can see the surface of the paper reflected in the mirror at all times. Remember - when the surface has a high gloss, leave it alone.

Maine Coast

290 x 460 mm $(11^{1}/_{2} \times 18 \text{ in})$ Much of this picture was painted simply, using a muted blend of colours applied wet-in-wet. Water content and timing are crucial if you wish to retain control when stroking colour onto a damp surface like this. The waves were mostly achieved with unpainted paper and the spray was pulled out with glasspaper once the painting was completely dry.

Skies

The sky is one of our most familiar subjects – just look up and there it is – so you might think there is really no excuse for painting skies that look unrealistic. Yet new painters find great difficulty in painting a convincing sky, and in depicting clouds in particular. Like most aspects of watercolour painting, the answer lies in getting the timing right and controlling the tonal variations as you work.

Feluccas on the Nile

 $340 \times 480 \text{ mm} (13 \, \text{V}_2 \times 19 \text{ in})$ A friend's holiday snap provided the inspiration for this moody painting. The graduated sky was painted wet-in-wet at the same time as the water, using Raw Sienna with a touch of Cobalt Blue and French Vermilion. The hard-edged ripples on the water were painted wet-on-dry using a stronger version of the same mixture.

Varying the colour

It is frequently suggested to beginners that they mix up a large amount of colour to cover the whole sky area so that they do not run out of paint, as it will be hard to match the colour exactly. This advice can be misleading, however. The very fact that you may not be able to mix the same colour twice can be an advantage, because the

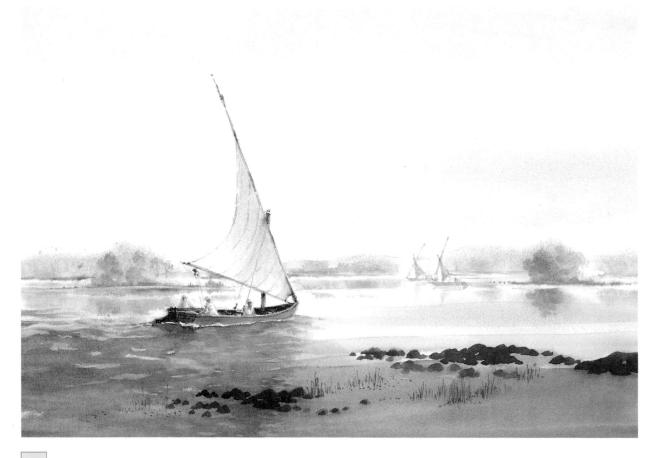

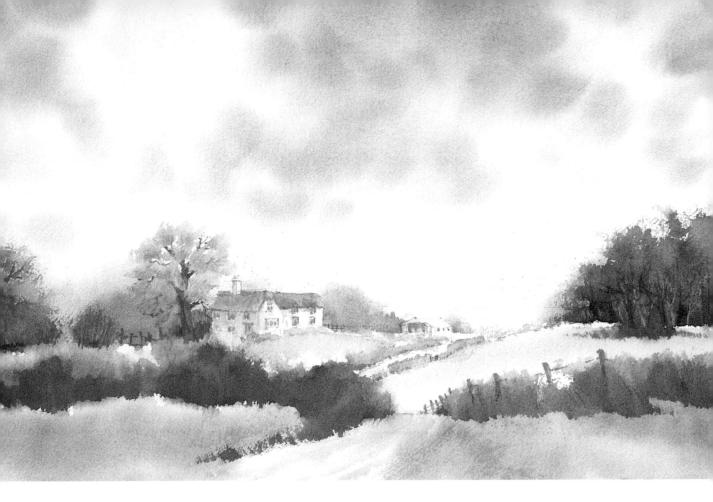

Cottage at Horton

345 x 460 mm (14 x 18 in)
The low-level horizon gives scope for a bold sky painted wet-in-wet using a 50 mm (2 in) hake brush. I used Ultramarine Blue and Burnt Sienna for the clouds, and added Payne's Grey, Lemon Yellow, Cadmium Yellow and Raw Sienna to produce the strong summer greens. I always think that Payne's Grey should be used with caution because it can overpower your painting and if used too much can result in repetitive-looking work.

last thing you want is a huge area of bland colour that resembles a painted wall. Even in a brilliant blue sky there are subtle changes of hue from one area of the sky to another, so any variation in colour that you introduce in your painting is likely to give it more realism.

Getting the mixture right

Most problems that painters experience stem from using too much water and too weak a mixture of paint with a consistency that resembles washing-up water. This is a disastrous combination. Knowing when and how to apply the colour is another important factor, as in most aspects of painting – correct timing is crucial. So use big brushes, stronger paint and wait for the paper surface to be receptive. Read on – mentally absorb – and let your paper do the same before you dash in with that brush!

Neutral Graduations for Peaceful Skies

My efforts to paint subtle, restful skies seem to produce rather bland results. How do I paint calm, atmospheric skies with just a wisp of cloud running across them?

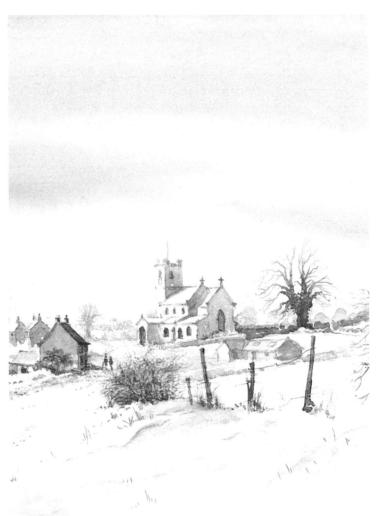

Snow, Morden Church

340 x 250 mm (13½ x 10 in) This church is located near to my home and I find the light shining on the roof makes it a very appealing subject even though the building is not very old. A limited palette was used to create this imaginary snow scene using mostly Raw Sienna, Cobalt Blue and Cadmium Red in various quantities. Graduated washes are fairly simple to paint, but timing is important. Damp the paper with clean water and allow the gloss to go off, then apply a graduated wash working from the top of the paper down to the horizon. This can be light to dark or dark to light, which helps to give the impression of depth. If you are working dark to light, start off with a strong mixture of paint because the dampness in the paper will weaken the mixture as you work down and assist the graduated effect.

Neutral colours have a calming influence and can be produced by mixing two suitable primary colours together and adding just a small touch of the third primary to grey the mixture slightly. Alternatively, take one primary and add just a small touch of each of the other two. Experiment with this method and you will find it very simple.

Add your wisp of cloud with a brush loaded with a slightly stronger mix of the same colour, but make sure the first layer of paint is not too wet. The paper surface should be damp with a dull sheen – but not glossy. Use smooth, confident horizontal brush strokes to whisk in the cloud shape – just a couple of brisk strokes are necessary, then leave it to gently blend on the paper. Avoid playing with the paint.

How To Make Sunsets Less Lurid

When I use strong, bright colours for sunsets they tend to look rather crude. How can I paint breathtaking sunsets that look more realistic and less lurid?

Mudeford Sunset

345 x 460 mm (14 x 18 in) This local harbour is a great place to catch a sunset especially if the tide is low. Warm colours were used for the early washes -Raw Sienna, Cadmium Yellow and Cadmium Red. The crisp edge to the sun is achieved by painting wet-on-dry. (For a soft-edged sun work wet-in-wet.) I used Alizarin Crimson with Ultramarine Blue for the heavier clouds and a pale wash of Cobalt Blue for the clear sky at the top.

My method is to paint bright underwashes and overpaint them with more neutral tints. I start with a

graduated background wash of, say, Lemon Yellow, painted light at the top to dark on the horizon, and then mirror this over the sea. When dry I overpaint a graduated wash of orange, wet-on-dry, leaving a crisp round shape for the sun. (For a softer shape, apply clean water over the sun first.) As this dries out, I paint heavier red, orange, blue, and violet cloud masses wet-inwet, pausing to allow each variation in colour to soak in, then paint matching streaks on the sea. If you neutralize these overlaid colours (as described on page 34) the bright underwashes will shine through, but not appear too garish.

Final cloud shapes can be added weton-dry, painted with ragged edges for a realistic effect. A very pale blue graduated dark to light wash can be applied over the upper sky, stopping just short of the top edges of the clouds to leave a light halo.

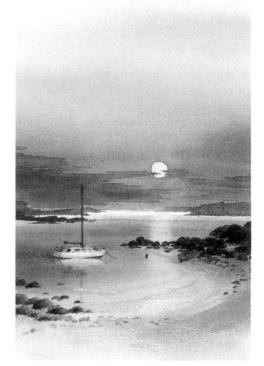

End of the Day
450 x 300 mm
(18 x 12 in)
A graduated wash of
Lemon Yellow was
overpainted when dry
with a little Cadmium

Red. Stronger colours were dulled slightly by adding a touch of Ultramarine Blue. Burnt Sienna was added to produce the dark rock colours.

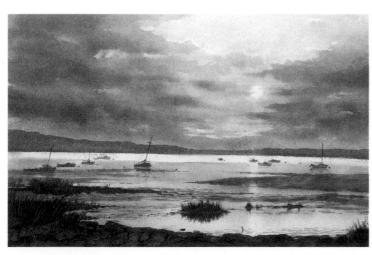

Wet-in-Wet Skies

I often mix three separate colours before painting sky and clouds – blue, grey and dark grey – but they never seem to match very well. How can I choose my colours so they harmonize better?

Evening Sky

360 x 480 mm
(14 x 19 in)
This was a classic case of wet-in-wet – the clouds were built up patiently, ensuring that at no time the surface dried too much or was too wet. The blue part of the sky was painted last, wet-on-dry.

There is really no need to mix your colours in advance like this. I suggest that you damp your paper all over with clean water before you start. While the water is soaking in, you can be mixing your blue. Try putting the colour on your palette and adding the water to it rather than the other way round. When you are mixing wet-in-wet a small amount of pigment will do and

it can be fairly strong, because the water is already in the paper and this will have the effect of lightening the paint even before it dries out. Do not apply colour till the gloss has dulled on the paper.

Having applied blue to the sky area, you can use it as a base to mix the grey cloud colour – this way the grey will harmonize with the blue. Simply add a touch of Raw Sienna and a touch of Alizarin Crimson to the mixture on

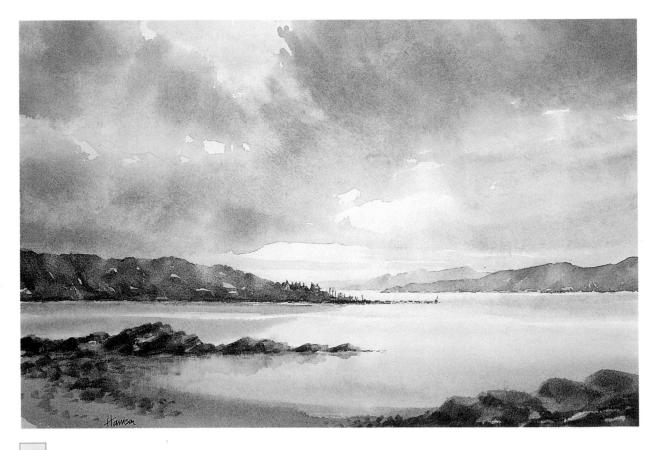

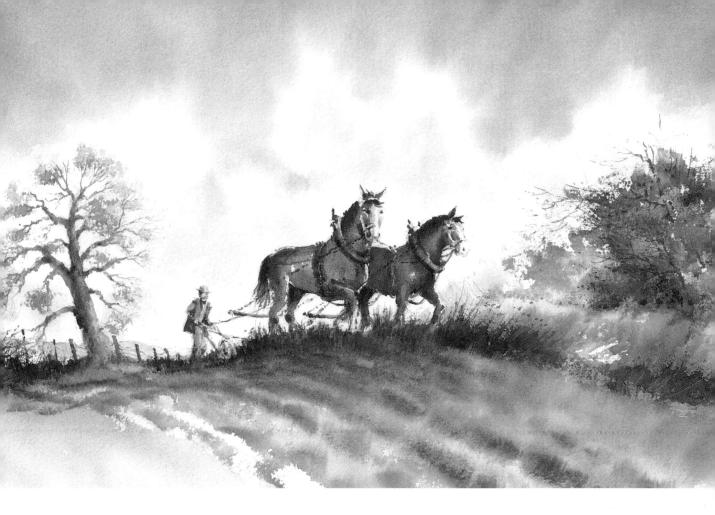

The Good Old Days

320 x 475 mm (13 x 19 in)
This imaginary scene was inspired by the discovery of two wooden shafts and a rusty plough behind an old shed at our home in the country. The low-level view isolates the main subject against the skyline, which is always effective.

your palette to produce a suitable grey that gives more body to the cloud shapes. Leave a few lighter gaps here and there and graduate the shading to give the clouds more form.

An alternative method is to mix Burnt Sienna or Burnt Umber with the blue used for the sky and this will produce a harmonious grey colour for the clouds.

If you are one of those people who spend a long time over each area of colour and your sky has dried out too much, allow it to dry completely. Then damp the whole area over again and when the shine has gone off the paper surface, paint the grey colour into the clouds. If your paper often dries out too quickly when working wet-in-wet, damp the reverse side of the paper before you start and you will find that the paper surface on the painting side will stay damper for longer.

DEALING WITH

Applying a weak, watery paint mixture to a very damp surface can result in pools of water forming on the paper and causing back runs or 'cauliflowers'. If one of these looks like appearing it can be nipped in the bud by quickly lifting the paper at the nearest edge to the problem and aiming a hair dryer at the underside of the paper in the

the underside of the paper in the affected region. Sometimes you may not notice the 'cauliflower' until it is too late, in which case allow the paper to dry out. Apply clean water and allow to soak in, then tease out the offending marks with a stiff bristle brush, wiping your brush clean on a piece of kitchen roll from time to time and applying more water as necessary.

Avoiding 'Dabbed Out' Clouds

When I paint the sky I use damp tissues to dab out my clouds, but they usually look flat and patchy. How can I achieve a cleaner, less static appearance? Is there a better way than dabbing out?

Leaving unpainted areas to suggest clouds when painting wet-in-wet can be effective. If the sky colour spreads too far into the white areas, however, it can be briskly whisked out in places using dampened kitchen roll. This method is far preferable to dabbing out clouds.

If possible, avoid dabbing out cloud shapes with damp tissue because the resulting clouds never look fresh and there is always a chance that you may pick up colour with one dab and deposit it back on the paper with another. The result – spotty clouds! Also, small pieces of tissue fibre can

For better results utilize the white of the paper for cloud shapes. As you paint the surrounding blue sky leave these areas unpainted to suggest the clouds. If the colour spreads into the

finish up in the wet paint.

areas intended for the clouds (because you will be painting this wet-in-wet) use a slightly damp piece of kitchen roll, not tissue, to briskly pull out the colour to reveal the white paper in a few places.

Work from the clear areas into the colour pulling the kitchen roll firmly into the blue colour, lifting as you go, to leave a soft edge. This action enlarges the white areas, but does not leave dull marks on the paper as long as you keep turning the kitchen roll to use a clean piece for each stroke. Avoid dabbing at the colour as this usually gives a messy result..

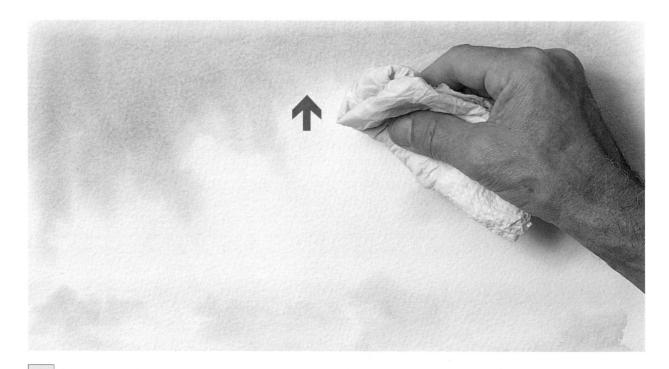

Clouds or Heavy Puddings?

However hard I try, my clouds are unconvincing. They appear as individual shapeless blobs or hard-edged cutouts. How can I make them look part of a real cloud formation?

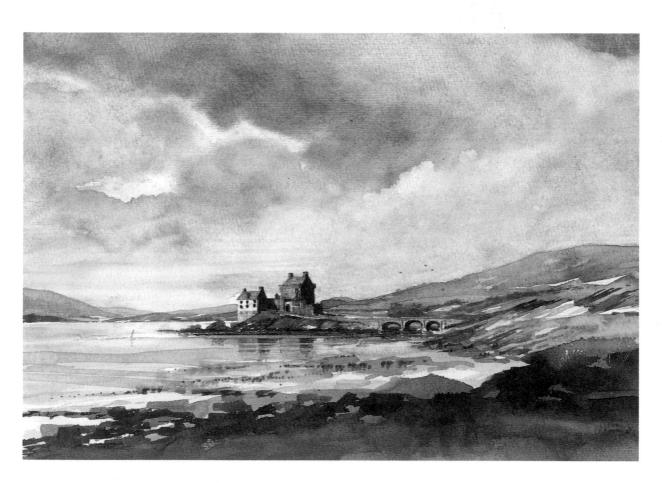

Eilean Donan

260 x 405 mm (10 x 16 in) Painting wet-in-wet permits subtle blends of colour. If the timing is right, as the paper dries a mixture of soft and crisp edges can produce interesting results. Nothing looks worse in a painting than hard-edged pudding-shaped clouds dominating the sky, so at

the drawing stage arrange your clouds in a variety of sizes to form interlocking shapes that enhance the composition.

Work wet-in-wet and wait for the gloss on the paper to dull before applying a strong mixture of paint. Too weak a mixture will result in an insipid look and may produce back runs or 'cauliflowers'. If you allow the surface to dry too much the clouds may be hard edged.

If you really want hard edges, paint them wet-on-dry and ensure the edges are regular. Soften them in places with clean water. Even heavy clouds should still have graduations of tone and some lighter areas to look realistic.

Adding More Drama to Sky Paintings

When I try to paint bold skies wet-in-wet and attempt to darken a cloud area, the colours blend too much and look bland. What can I do to make my skies look more dramatic?

To add more drama to sky paintings you need to work with stronger colours than usual and create greater contrast between the light and dark areas, forming dark shapes with light gaps showing here and there.

Most problems arise because the paint mixture being applied is too weak and watery and not strong enough to allow for the effect of the inherent dampness in the paper. This is easy to overcome by using a stronger mixture of paint. (Remember – even a really strong colour will lighten as it dries, so allow for this.)

Other reasons for a disappointing result are poor timing in applying the paint and using small brushes. You cannot paint a big, bold sky well using a tiny brush, so use the largest one you can handle. You must also wait for the first layer of paint to soak into the paper and for the surface gloss to change to a dull sheen; then the newly applied paint will be more controllable. The colour

Tree at Bulbury Woods

290 x 400 mm (11½ x 16 in) This dramatic scene was painted under hot studio lights during the making of a video and therefore required brisk action. I masked off the tree and main branches so that I could paint the sky area without holding back. Since watercolour dries so much lighter, I used what appeared to be much too dark a mixture for the clouds, but it looked about right in the end. Try to allow for this change in colour.

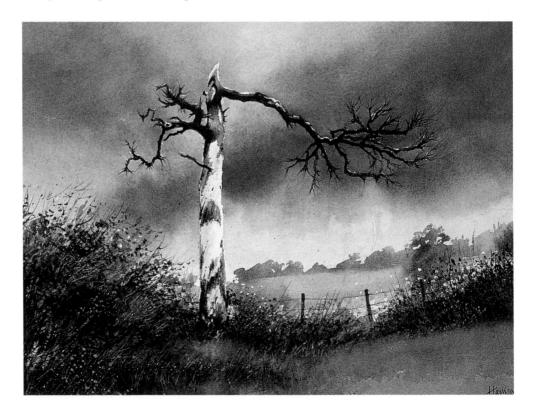

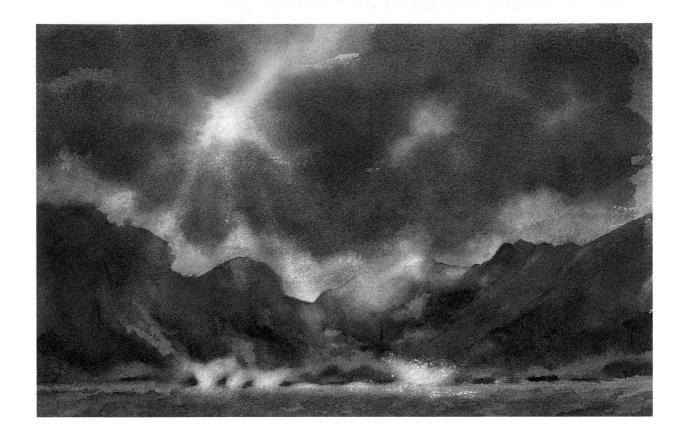

OVERPAINTING FOR GREATER IMPACT

If your sky looks a little pale and you would prefer it stronger or darker in colour, allow it to dry, then damp it all over with clean water. Wait for the shine to go off, then apply another

layer of paint. You can use this technique for any area of your painting, but use a large brush when you apply the clean water and brisk, but gentle, brush strokes to avoid picking up the underlying washes. To work just on the sky area, turn your paper upside down to avoid clean water running down and spoiling the area below.

Always take sky washes down behind trees to the horizon because the colour needs to show through the gaps in the foliage. If you think the sky colour may affect the colours of the leaves, all you need to do is lighten the wash in that area with clean water.

will fade less as it blends in and the paint will not spread out to form one large blob.

I usually paint this type of scene wetin-wet because it is easier to build up the heavier cloud masses while still retaining soft edges. Make sure you balance dark clouds with other features and also reflect the same colours in any water feature lower down in the painting that reflects the sky. To give the appearance of falling rain, apply a band of clean water just below the cloud masses, allow it to soak in for a few moments, then gently blend the wetness into the underside of the clouds and the cloud colours will spread gently into the dampened area. Be careful with the arrangement of the clouds and the strength of colour. Leave lighter gaps here and there and vary the tone to make them look more rounded. Do not just make a series of very dark shapes, otherwise they may look like black holes in the sky.

Storm Brewing

230 x 360 mm (9 x 14 in) This was just a doodle in a quiet moment, but the result was an interesting and dramatic painting. Sometimes, it is helpful to just play around with colour and not concentrate on any particular subject. The result can often be the inspiration for a further painting.

6

Hills and Mountains

Many people experience trouble painting hills and mountains, which often finish up looking like flat daubs of colour with no real form. To make matters worse, a range of mountains is frequently shown as a series of similar-sized mounds rather like ice-cream cones on the horizon. The resulting uniformity makes an unimaginative and boring picture.

Swiss Valley

335 x 485 mm (13 x 19 in)
I photographed this scene en route
from Berne to Montreux. There were
some beautiful yellow flowers in the
foreground, but somehow they did not
seem right for the picture. The snow
on the distant mountain peaks was
formed by leaving the paper unpainted
– this is always a good idea if you
want a fresh-looking result.

Varying the shapes

Try to develop more variety in the shape and bulk of your mountains and background hills, perhaps painting one large slope offset or balanced by two smaller ones. Vary the colours, tones and shapes, and overlap peaks for added interest. You should solve any problems of composition at the planning stage of your painting.

Evening Calm

290 x 455 mm (11½ x 18 in) I started this scene at a workshop, continued it for a video and finished it some time later. This is not the ideal way of producing a painting, but it does give you time to ruminate. I prefer to sit down and finish a painting in one hit, but I recommend that you walk away from it from time to time, because each time you return to it you will probably see it in a different light.

Making forms look three-dimensional

To achieve a three-dimensional effect on flat paper your brush strokes must be directional to emphasize shape and form, so when you are painting hills or mountains shape your brush strokes to match the undulations in the terrain. If you do this, any unpainted strips or dark bands of colour left by overlapping brush strokes will follow the correct contours. Try to introduce subtle variations of colour rather than painting the whole area with one hue, which looks flat and uninteresting and gives no indication of the nature of the surface. Start by blending colours on the paper wet-in-wet, then allow the paint to almost dry before adding more layers of colour. With each application of paint, leave parts of the earlier layer unpainted to show as lighter streaks. Finally, add more detail wet-on-dry to create tonal contrast between different areas. Your hills will come alive!

Painting Hard and Soft Edges to Form Distant Peaks

My hills and mountains all look the same and seem to lack dimension and perspective. How can I create more variation and make them look more imposing, yet distant and misty?

Distant mountains and hills usually appear pale in colour because we see them through vapour and dust particles in the atmosphere, producing the effect known as aerial perspective. We can emphasize this in our painting to give added depth by using pale washes of blue or blue-grey. For crisp edges to mountains, wait for the sky area to dry out completely.

For painting these peaks, I usually use the chisel edge formed by the bristles of a 25 mm (1 in) flat brush and a downward or slanting movement with the brush held at about 45 degrees.

Painting wet-on-dry allows you to make a crisp outline at the top using a firm downward slanting brush stroke. Applying a little extra pressure at the bottom forms a darker edge, which can indicate both a level horizon and a suggestion of a hedge or even a rocky shore. All the time, blend the colours on the paper for added interest, retaining the pale tones to keep them looking distant. Paint the nearer ones with stronger, warmer colours.

If you want part of a distant hill or mountain to blend into the sky, paint it when the sky wash is still slightly damp, not wet, and in places blend the colour

Welsh Valley

340 x 540 mm (13½ x 21½ in) I painted the distant mountains while the sky area was still slightly damp. Then I added darker bluegrey tones to the clouds, pulling the colour down over the mountain tops just before they dried out to allow the colours to blend gently on the paper. Avoid doing this if the paper surface is still soggy or you will risk back runs. The tops of the nearer peaks were painted on dry paper to achieve contrasting crisp edges.

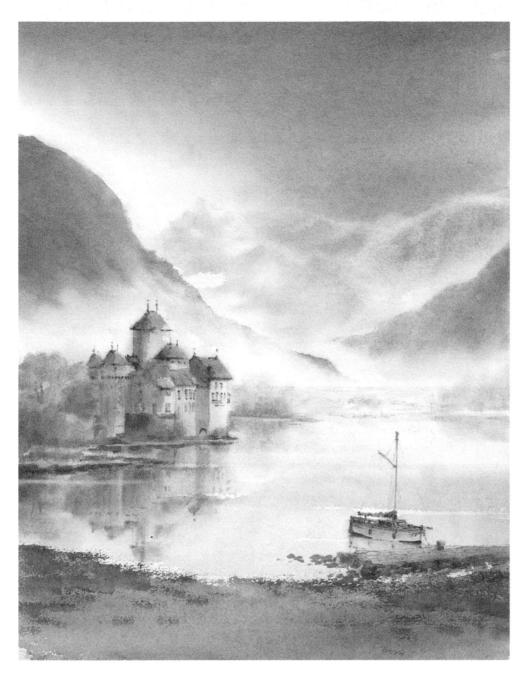

Château Chillon 455 x 330 mm (18 x 13 in) I have filmed and photographed this dramatic scene in both sun and mist but I decided that using neutral colours would be an appropriate way to paint the calm waters of Lake Geneva. I mixed Raw Sienna with a touch of Cobalt Blue and French Vermilion for most of the painting.

gently up into the sky. If you wish to strengthen the colour in places, allow the paint to almost dry, then blend in a touch of colour with a sloping brush stroke to emphasize the slope of the hill or mountainside.

To achieve the effect of rolling mist, paint the top part of the mountain, then leave a small gap and apply a band of clean water below. Allow this to soak in for a while. Then work this dampness up into the still wet paint above and the paint should blend gently down into the

damp area, creating a soft edge. If you rush this process and the paint and the clean water are too wet, a nasty stain can form, so do allow each to soak in for a while before proceeding. Alternatively, the mist can be lifted out using a sponge, a clean piece of damp kitchen roll or a stiff bristle brush, but the result will not be as fresh. To continue the lower part of the mountain or the fields below, wait for the shine to go off the dampened area, then blend in a little colour and continue painting.

Positioning Land Masses to Establish Distance

I experience difficulty placing mountains and headlands in the right order. How do I arrange land masses to get more depth and stop them looking as if they are running downhill?

When you draw a series of receding headlands, think of them as separate planes advancing progressively towards you. (Imagine you are sitting in the upper circle at a theatre and viewing the stage scenery.) Draw the baseline of each headland lower, the nearer it is to you. This sounds obvious, but people often get it wrong. Make sure each base line is level. Water cannot flow uphill! If you draw each

baseline horizontal, but uneven, it also helps to prevent the impression of the water running downhill.

When it comes to painting distant headlands, pale bluish tints will give the right effect. For closer land masses the colours will need to be warmer and stronger the nearer they are to you. This change of colour and tone emphasizes the feeling of distance between the various peaks. I usually use a 25 mm (1 in) flat brush to paint these

Arrange distant headlands carefully in the planning sketch. They need to be drawn in sequence, keeping the base lines more or less level. The nearer the headland, the lower the base line in your painting, and this establishes distance.

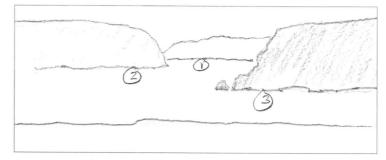

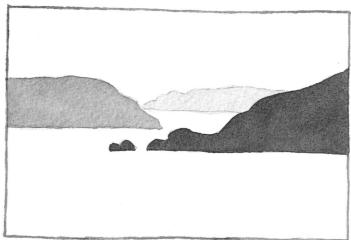

To increase depth in your picture paint the far distant headlands in pale tones and use stronger tones for land masses that are closer to you. The contrast between them will help establish their position in the scene.

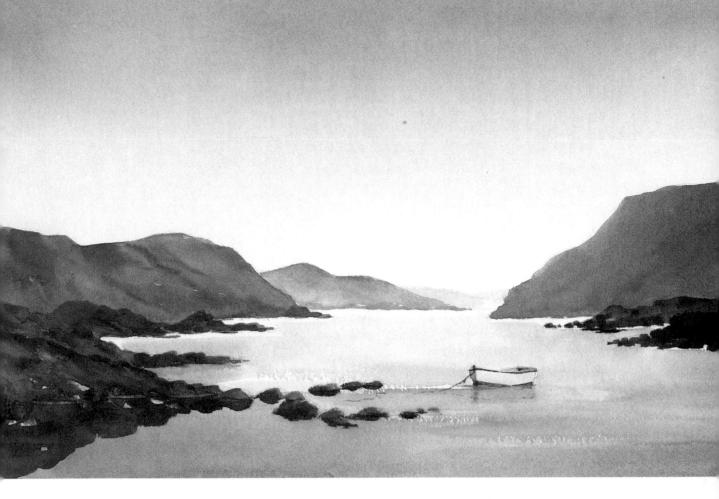

Dusk on the Loch

345 x 460 mm (14 x 18 in) This simple painting is a good example of how to give the impression of distance by varying the tonal values of the different mountain peaks and using warmer and stronger colours as each one becomes closer. My graduated washes are usually much more uneven, but on this occasion the paint blended perfectly - a rare moment.

headlands because it is simple to achieve a crisp top edge as well as the flat baseline necessary. Brushing the bristles backwards and forwards on the palette gives a thin chisel edge to the bristles to create the top edge of the land and the brush can be pulled down the appropriate distance to make a flat base. By applying a gentle pressure on the paper here, it is easy to make a heavier mark, which may suggest a line of rocks at the water's edge.

Do not try and paint a horizontal line with a round brush unless you have a really steady hand. If you need to do it this way because you do not have a flat brush, turn your paper sideways and you may find it easier to pull the brush down vertically.

If the baseline looks a bit rough, or appears to slope up or down, hold a piece of white paper horizontally above it to establish the correct line and gently tease out the surplus area of paint with a dampened bristle brush.

PAINTING SKY BEHIND LAND MASSES

Many painters stop the sky colour at the top edge of mountains or headland and paint around the shapes. This leaves a hard edge when dry that is impossible to match with the next layer, so some unsightly overlapping can occur. Always take the the sky colour right down to the horizon, lightening it with clean water behind the headlands if necessary. In seascapes, continue the process in reverse from the horizon down to the bottom of the page to show the sea reflecting the sky. When this is dry the mountains and headlands can be painted wet-on-dry. A narrow, horizontal unpainted strip of water can be left on the horizon to suggest light reflecting on the surface and this will enhance the feeling of depth.

Using White Paper for Snowy Mountains and Hills

I would like to paint some snow-covered mountains and hills, but I do not usually use white paint. How do I paint the snow without using opaque colour?

If you use unpainted paper to suggest snow, there is no need for opaque paint, which invariably looks dull and lifeless when used on a watercolour. A tonal sketch will help to establish right from the start where the snow is lying and which areas of paper are best left unpainted.

Even in snow scenes I paint a very pale background wash of Raw Sienna in places with a hint of Cadmium Red in the sunny areas. If allowed to dry before overpainting, these colours shine through any subsequent shadow washes and add warmth and interest to otherwise dull areas.

To suggest snow-covered mountains, I turn the paper upside down and paint the sky from the mountain tops to the top edge of the paper, leaving an unpainted gap to form the snowy peaks. To give shape to these, paint the shadow side with a pale wet-in-wet wash of blue or violet. When this is dry, slightly stronger shadows can be overpainted wet-on-dry to give crisp edges to the ridges and crevices.

Icy Morning

345 x 460 mm (14 x 18 in) I took far too long over this painting, which is why it looks a bit mechanical, but the white of the paper certainly shines through to suggest the distant mountain peaks. I used masking fluid in places but laid it over the underwash once the paint had dried. This usually makes it easier to lift off afterwards.

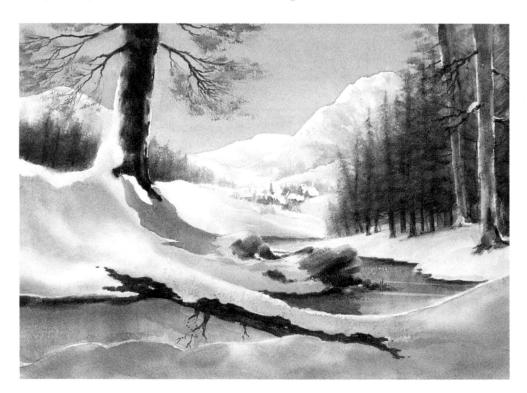

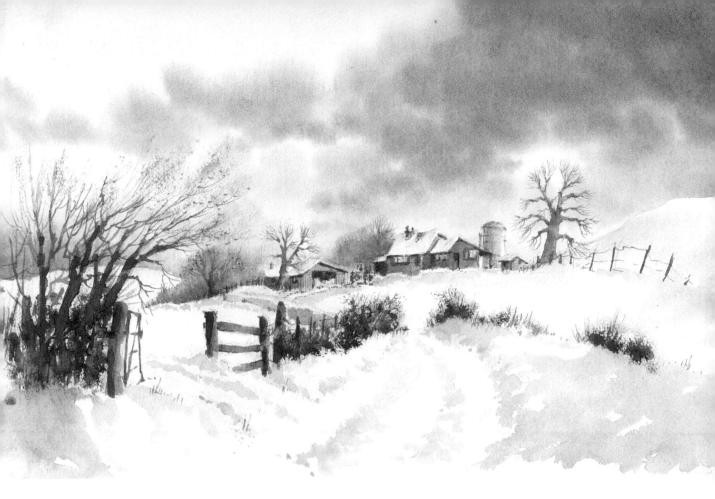

Sundown

330 x 480 mm (13 x 19 in) My first serious picture when I resumed painting a few years ago was of this scene. For this version I introduced a dramatic wintry sky. I turned the painting upside down to paint the sky, starting with Lemon Yellow adding French Vermilion while the paper was still wet then mixing Cobalt Blue to the French Vermilion to overpaint the big clouds using a hake brush throughout. For bold skies use a big brush. All the lightest areas of snow are simply

unpainted paper.

A lot of pure white is not always evident in snow-covered locations because much of it is in shadow and some of it reflects the colours from the sky or nearby objects. When painting the scene, sparingly featuring small areas of pure white can add great impact if most of the snow is painted with pale blue tones. Watch out for variations of tone in the shadows, which can be painted with pale washes of blue, grey or blue-violet away from the sun and with warmer tints of peach and yellow on the sunny side. These can be used for gentle undulations in the snow surface. For stronger shadows and crevices, use blue-violet wet-on-dry, then overpaint deeper ones with darker bluegrey colours.

Snow scenes need careful planning and in this case a monochrome value sketch in blue is particularly useful, and excellent practice because it offers an opportunity to arrange contrasting areas of tone that will be similar in colour to the finished painting.

BRUSHING UP ON SNOW SCENES

Many amateur painters find snow paintings a problem and employ aimless brushwork that fails to convey the nature of the land beneath the snow covering. As in normal landscapes, the undulations in hills, fields and bushes neds to be brought out by convincing brushwork. So, when applying initial tones to snowy areas, work wet-in-wet using large brushes and sweeping strokes that match the curves and dips in the land. This will produce areas of graduated tone that communicate to the viewer that they are not looking at a flat expanse of countryside. Deeper shadows and tones can be added for emphasis, again matching brush movements to the surface variations. Make your brush strokes meaningful!

7

Trees

Trees have always been at the very heart of landscape painting and this is the area that seems to give painters most problems. Most of us see trees every day of our lives, yet many of the trees created by painters are just not realistic. The sensible move is to simplify the shapes as much as possible. There is a wide variety of tree shapes to choose from and it is not necessary to draw them with total accuracy unless you are producing botanical illustrations.

Common problems stem from poor observation, incorrect brush techniques and a desire to be too precise and paint every leaf and twig. Often, the shapes produced are so obviously wrong, yet there is plenty of reference material available for you to use. Most painters' trees would improve if they used a big brush laid almost horizontally on the paper for the foliage (not

Through the Pines

390 x 350 mm (15½ x 14 in) These magnificent pine trees, which have been assailed with golf balls due to their prominent position on a Dorset golf course, overlook a far-reaching view. As the leaves of deciduous trees turn to russet during autumn the pines stand out even more strongly when the sun sinks out of sight. I used Lemon Yellow and Ultramarine Blue for the foliage, which I applied with a small squirrel mop brush used on its side, and added a touch of Alizarin Crimson to tone down the strong colour to suit the time of day. I dry brushed the texture on the trunks with a dull grey-blue mix after applying a light underwash of Raw Sienna.

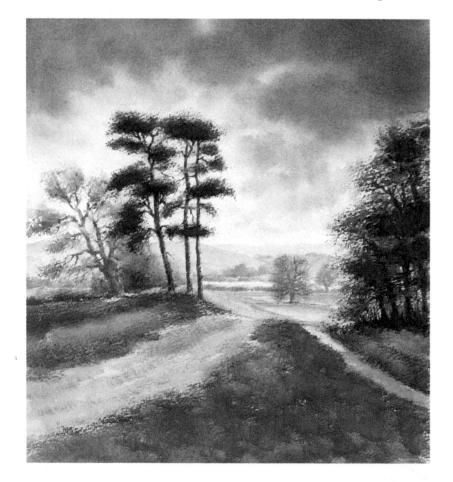

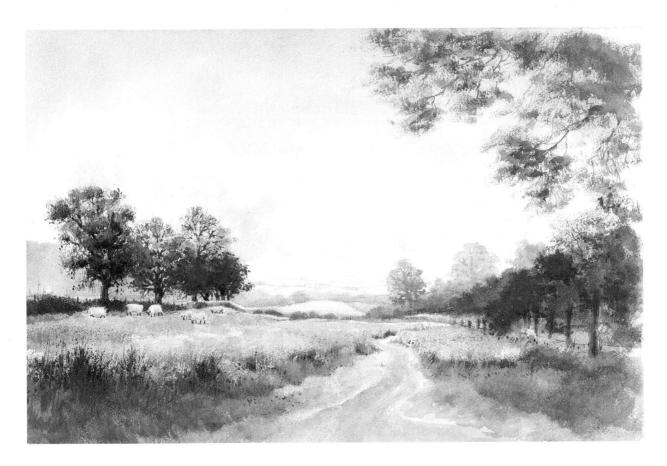

Spring Morning

340 x 510mm (13½ x 20 in) This scene is typical of a spring morning in the country with light fresh greens dominating the scene. I kept the distant trees pale and cool in colour so that they appear indistinct, and the lines of hedges and trees in the foreground lead the eye to this area. I used mostly Lemon Yellow and Cobalt Blue throughout the painting, with a touch of Raw Sienna and Cadmium Red for added warmth. The strong light from the left results in more contrast in the large clump of trees and strong shadows in the hedgerow. The sheep were formed by painting the green colours of the hedge and field around them, leaving white unpainted areas of the paper in the shape of the sheep. Blue-grey shading gave them more form. Overhanging branches were painted with a hake brush.

a technique usually recommended) instead of dabbing away with the point of a round sable.

Seasonal changes

Watch the trees through the seasons and you will find the varied colours a delight. In spring the colours are noticeably cool and fresh, so mix Lemon Yellow and Cobalt Blue for clear greens. As summer approaches, the colours become warmer and richer, so Cadmium Yellow and Raw Sienna can be mixed with Ultramarine Blue to take account of this. In autumn, warm colours are dominant and you can create a range of subtle orange hues by neutralizing bright oranges with a touch of blue. Use warm reds such as Cadmium to warm the brown and gold colours of the remaining foliage. In winter, darker browns and blue-purples can produce a cooler appearance, with the occasional warm orange-coloured bush introduced for interest and contrast.

Painting tree trunks

Tree trunks are a wide variety of colours, including grey, greens and orange-browns. I paint them using a light colour mix of Lemon Yellow and Raw Sienna, then build up more colour in stages adding touches of blue or red.

Giving Leafy Trees More Body

The foliage on my summer trees looks too even and the colours go muddy and merge so that the trees look shapeless. How can I give them more structure and make them look real?

My way of painting individual trees is to indicate their position, height and main branches and leave the rest to the brush. I do not worry about what type of tree it is; most trees fit a fairly standard pattern of construction and shapes within a range of styles and I give these a nickname to remind myself.

Even though you cannot see the underlying branches on a summer tree thick with foliage, it is still sensible to start by roughly indicating the outer shape lightly in pencil and sketching in the position of the main branches. In this way the outer extent of the foliage is easier to constrain and the leaf clusters can be painted in a more logical fashion, so that they hang on the supporting branches.

My usual rule is to paint summer trees in a particular order – foliage first, leaving gaps for the branches to show through; then the trunk; and then branches in the gaps in the foliage. (Winter trees are painted trunk first, followed by thick branches, then finer branches and remnants of leaves.)

This method can pose problems for some people, because they find it hard to leave gaps in the foliage through which the supporting branches show and a painting can look amateurish if branches are painted over the foliage. To avoid this, after drawing the tree shape and branches, erase the sections of branches where the leaf clusters will cover them, then the remaining short lengths of branches can be painted in the gaps. The foliage can be built up, using a fairly dry mixture of paint, starting with the lightest colour. For example, a mixture of Raw Sienna and Lemon Yellow might be followed by

I call this the 'ladies hairdo' shape. It is typical of ancient Oaks and is upwardly mobile in growth pattern.

The 'lollipop' – a typical rounded shape. On some versions the trunk is slimmer and the branches grow more upright.

partial overpainting in a darker mixture with a little blue added and even a touch of Cadmium Red. Each layer should be allowed to almost dry before applying stronger, darker mixtures to give body to the leaf clusters.

If the colours on your painting go muddy it is probably because your paint mixture is too weak or you have added too much water and you have applied each layer of colour to your paper without checking first to see if the previous application of colour was almost dry. The result of applying more

runny paint while the paper is still wet is that each succeeding layer of colour merges with the previous one on the surface, producing a dull, muddy effect. To prevent this, after applying each layer wait for the shiny wet surface of the paper to dry a little and go dull before applying the next one. Ideally, you need to look at the surface of your paper against a strong light source that will reflect on the damp surface and allow you to assess the degree of wetness.

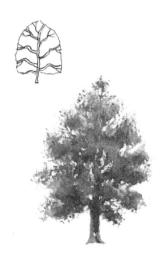

The 'flat iron' shape. The tree has a slim central trunk with branches that grow slightly upwards.

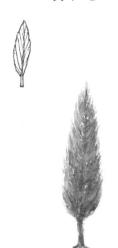

The 'spear' shape. Column-shaped trees have most branches growing upwards from a slender central stem.

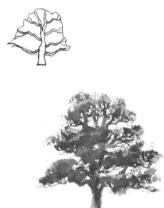

The 'helmet' shape. The trunk often splits into two or three main stems; most branches grow horizontally.

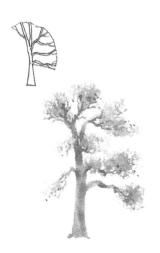

The 'half-open fan' shape. This is a bit one sided, so an odd branch on the other side adds variety.

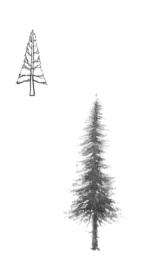

The 'cone' shape. The branches may grow sideways and downwards, or sometimes slightly upwards.

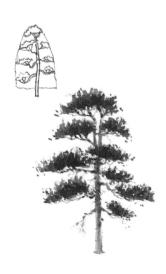

The 'bullet' shape. The trunks are tall and slim. The branches are staggered, growing sideways and slightly down.

Making Winter Trees Look Three-Dimensional

My winter trees always look flat and lifeless. The branches do not seem to come out at the correct angles. How can I paint branches to suggest some growing towards the viewer and others away?

Many amateur painters, even those who are keen gardeners, produce trees with straight cylindrical trunks with branches sticking out of the top like flue brushes. Trunks seldom grow straight up, so try not to draw them that way. They often lean away from the prevailing wind.

Trees are growing things – just like people – and, like people, they vary in height, width and appearance. Think of the branches as being like arms, growing more slender towards the extremities; and the twigs like fingers, sometimes pointing up and sometimes pointing down depending on the type of tree you are painting.

It is also helpful to consider the branches as a series of gradually tapering cylinders that become thinner at each joint where they change direction. These are fairly straight sections, not sweeping curves as they are often painted. Some branches grow up towards the light, some sideways or down. When you draw trees, indicate the general shapes very roughly, because they will look more natural if most of the work is done with the brush.

Branches growing upwards and away from you face the sky and catch the light. Branches growing upwards and towards you appear to be darker because you are seeing the underside that faces the ground. If the branches

Shading and tones on the trunk and branches of a tree are easier to visualize if you think of them as simple cylinders. Placing the tones and cast shadows correctly emphasizes the curved nature of the structure.

Peace

340 x 290 mm (13½ x 11½ in) I masked off the main shape of the winter tree to allow me to paint the sky freely. After this was dry, I used a Raw Sienna underwash to indicate the trunk and heavier branches, leaving small gaps for the snow nestling in the angles between trunk and branches. Then I added stronger colour with Ultramarine Blue and Cadmium Red applied wet-in-wet at first, then wet-on-dry, to make darker shadows here and there. By virtue of the shading applied, one of the two lower branches appears to grow towards the viewer while the other grows away.

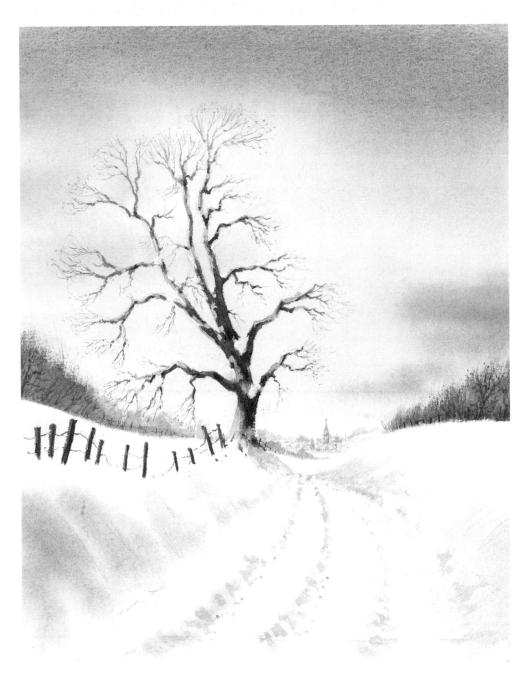

are growing downwards the opposite principle applies.

On a bright day the branches throw shadows onto the trunk and onto other branches and these shadows curve round, emphasizing the contours of the tree. By painting in these shadows, your trees will look more realistic.

Shading on the trunk should be painted on the side away from the light, but not right to the edge, because reflected light lightens that edge as well – look at any cylindrical object to see

this for yourself. The shaded areas will be a bluer tone of the colour they fall on, so do not make the mistake of painting them black. A light wash of blue-violet will allow the base colour to show through and the same mixture can be used to paint the cast shadows on the ground. These will follow the contours of the terrain and can be used to good effect to enliven your painting.

Painting Woodland Tree Clusters

I have great difficulty painting heavily wooded areas. They become masses of flat muddy colour with no shape or form. How can I paint them so they retain a sense of depth?

The first step is to produce a tonal sketch – if you can achieve the right effect in one colour the final painting should be easy. Work from light to dark as you will in the painting and you will probably find it easier to build up the wooded areas in layers.

Approach the finished painting in much the same way as the value sketch, starting with the pale, cool colours for the distant tree clusters and avoiding any detail. Middle distance trees should be indicated with slightly stronger colours and a little more detail, but not

too much. Even though the colours are not dark at this stage it is important not to apply weak, watery mixtures while the paper surface is still too wet because this will cause excessive blending and muddying of colours. Timing is crucial!

Foreground trees can be overpainted in stronger, warmer colours. Using this method, it is possible to paint multiple groups or lines of trees in layers, each one a little stronger, warmer in colour and larger in size. In the early stages it may be helpful to let the layers merge by painting each layer before the previous one has dried completely so

The Backwoods

350 x 520 mm (14 x 21 in) When distant hills are covered in dense clusters of woodland they can only be suggested, not painted in detail. In the far distance tonal values need to be kept light and in this case I used pale Cobalt Blue. For those in the mid-distance, I used shades of yellow-green using short upward strokes with a dryish mixture to achieve a vertical look and emphasize the rough tops to the trees, taking care to vary the height. The nearer trees were painted in more detail with warmer, darker colours to make them stand out against the distant ones.

Bluebell Woods

350 x 260 mm (14 x 10½ in)
A pale line of distant trees was painted first, and when these were almost dry a further layer was introduced, using slightly stronger colours and tones. This process was repeated to build up the woodland cluster in the background.

The colours used were mostly Raw Sienna and Lemon Yellow with a touch of Cadmium Red and Cobalt Blue to produce a range of fresh greens for the foliage and greyed greens for the trunks.

Ihe light trees were masked off and painted last. The bluebells were painted wet-in-wet to start with, leaving a light patch through the middle of the painting. More detail was added wet-ondry, using Cobalt Blue with a touch of Permanent Rose.

there will be some wet blending and some dry-edged trees. This looser approach will help to create the feeling of depth in the painting.

Define foreground layers more sharply by painting wet-on-dry to make them stand out against the pale background. Avoid placing individual trees in rows like soldiers, and use a variety of different shapes, sizes and colours. Arrange natural groupings that balance and complement each other. Paint foliage in stages, working from

light to dark and avoid covering a layer completely as you overpaint so that some of the lighter tones applied in the early stages show through each new layer. I use a large brush, which keeps it looking loose. Allow one layer to almost dry before applying the next and you will get an interesting combination of hard and soft edges. Use darker tones to emphasize form.

Blending Trees Into the Sky for Atmosphere

I would like to blend my distant trees into the sky to make my snow scene more atmospheric, but I am not sure how to achieve this. Mine seem to look washed out and unconvincing. Why is this?

Winter

320 x 370 mm (13 x 19 in) In this painting I wanted to depict one of those misty winter days when the sky seems to envelop the ground and has a dull yellow tinge to it. I damped the sky area down to the horizon line and painted a graduated wash using a mixture of Lemon Yellow with a touch of Alizarin Crimson and Ultramarine Blue.

I allowed the colour to soak in and when the paper surface was only a little damp I painted the vague shapes of the distant trees, using the same paint mixture, but increasing the amount of blue. As this dried out I inserted trunks into the spaces I had previously left unpainted. More trees were added using a stronger mix of paint.

When the painting was nearly finished I used glasspaper to pull out the white speckles on the tree tops to suggest frost and areas of snow.

The main problem is that your paint mixture is probably too weak and watery. For summer or

winter scenes soft-edged trees can be painted up into the still damp sky area with pale colour, but you must avoid having the brush swimming with paint.

Work from the horizon upwards, ideally using a flat 25 mm (1 in) brush, to achieve a reasonably straight lower edge to the trees. Timing is important – if the paper is too damp the colour may bleed too much into the sky area.

Another method is to damp the sky area with clean water down to the

horizon, then allow the glossy shine to go off the paper surface and brush in the trees wet-in-wet. Only damping down to the horizon line avoids surplus colour bleeding into the area below, which is important in snow scenes.

If your painting is completely dry, you can still add soft-edged trees by damping the paper above the treeline with clean water and when it has soaked in the tree line can be painted up to the dampness, where it will blend gently into the paper. Colours will be quite subdued in the distance, so use neutral mixes.

Portraying Light Trees on Dark Backgrounds

I like to include light colour trees against dark ones in my woodland scenes, but whenever I scrape out a tree or branch, why do I always finish up with dark lines instead?

An easy way to show light trees on a dark background is to scrape out the shapes with the point of a painting knife when the paint is almost dry. You can also use a piece of old credit card for this effect.

Another way is to leave white paper to suggest the trees by painting round them. This gives a similar result to using masking fluid but is quicker.

Whatever you use to produce this effect – an old credit card, finger nail or coin, for example – timing

is all important because you are working into the damp paint on the paper surface. If you try to make the marks when you have applied paint that is too wishy-washy and the paper surface is consequently too wet, or if you use a thicker mixture but go in too soon, the result will always be a dark line because you will simply gouge the paper and the wet paint will fill the groove. The answer is to use a strong,

creamy mixture of paint and allow it to almost dry before making your scraping action. If the timing is right the paint will be pulled clear of the paper surface and since it is a dry mixture it will not run back into the groove because the indentation is in the paint and not the paper surface. I prefer to use a painting knife for scraping out as it is more controllable.

Another method is to paint dark colours around the tree shapes, leaving the unpainted paper to suggest trees.

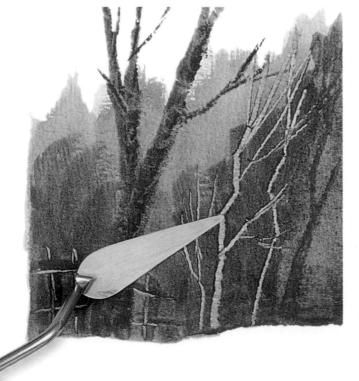

Water and Reflections

Water and reflections are constantly moving, so it is no surprise that many artists experience problems in painting them. Because water reflects the sky I usually start by painting these two elements together, after completing any underwash, so that the colours harmonize. You can add a feeling of depth to a painting by graduating the sky from dark to light, and the water light to dark, or vice versa.

I use large brushes for painting water, applying the paint with horizontal brush strokes. Remember that water does not flow uphill!

Painting the sea

When you paint the sea, you will notice that there is usually a band of light on the water just below the horizon and it is helpful to emphasize this in your

Low Tide at Lyme Regis

360 x 510 mm (14 x 20 in)
Even though it was low tide when I painted this scene, I worked on the sky and water together because the shallow water and damp mud still reflected the colours of the sky. The dark tufts of weed were overpainted with a strong mixture of paint, using the heel of the bristles on a hake brush. The variety of stranded boats creates an interesting arrangement of shapes on the mud.

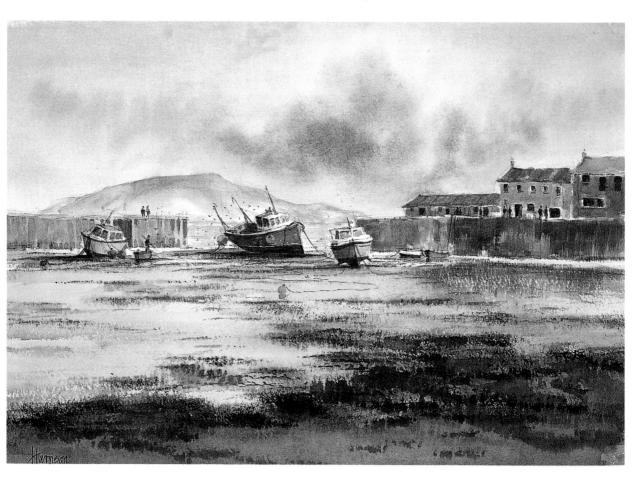

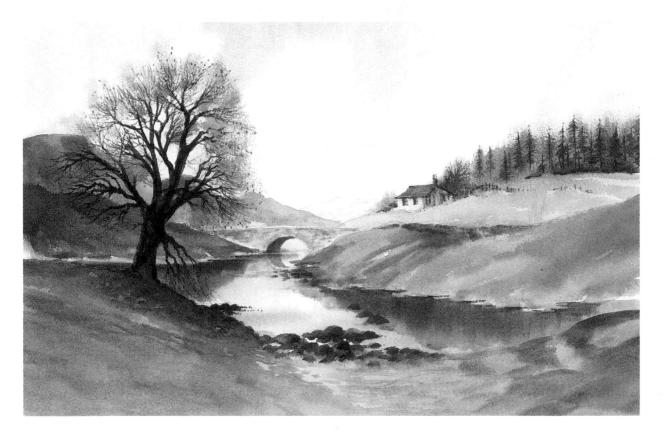

Morning Reflections

340 x 510 mm (13½ x 20 in)
An imaginary scene like this is ideal for practising reflections, all of which are painted wet-on-dry for crisp edges.
Notice how the bridge reflection is almost a mirror image of the bridge itself. The water has been painted using the same colours as the sky, but with horizontal brush strokes. The contrasting darker colours of the rocks and riverbanks add to the impression that this is a flat area of still water.

painting. If the sea is calm you may see the dark reflections of nearby boats and distant headlands, but even a slight movement on the water will diminish the effect. Reflections close to the shore are usually broken by the waves and probably best painted wet-on-dry to echo the shape of the waves.

Still water

Lakes are generally flat and calm, acting as a mirror for the sky, so it is even more important here to match the colours and shapes in the sky. Reflections of boats, headlands or trees will be almost mirror images, but notice that light objects reflect as slightly darker and dark objects as lighter. For crisp reflections, paint weton-dry and for soft ones, paint wet-in-wet.

Rivers and streams

Rivers and streams should meander gently, so keep the banks ragged and not hard-edged. If the water is light in tone, a dark bank will make it stand out. As water is usually a shade darker than the sky, overpaint it wet-ondry for more strength, leaving a few unpainted horizontal streaks for good measure. Where trees overhang a river or lake the water may well be darker and greener because the sky reflections are masked by the foliage.

Painting Still Water and Reflections

Whenever I paint lakes and ponds it is always difficult to tell where the land ends and the water starts. How do I paint still water so that it looks like water and with realistic-looking reflections?

The Fishing Trip
340 x 500 mm
(13½ x 20 in)
The water is fairly still
on this lake, but the
soft reflections,
painted wet-in-wet,
suggest a gentle
breeze. A reflection of
the streak of cloud
low in the sky has
been hinted at on the
distant water.

Paint the water at the same time as the sky. Make sure that the reflected image on the water surface mirrors the colours and general appearance of the sky. If the sky is dark overhead and lighter on the horizon, then the water should be the same – lighter on the horizon, but darker close to you where it reflects the sky above. Separate the water from the land mass by painting

darker edges along the shoreline; this will throw the water surface into sharp relief. Reflections of surrounding objects will define the water.

If your viewpoint is above the waterline, reflections will appear lower in depth because they will be foreshortened by the angle of view. For crisp-edged reflections, paint wet-ondry, but for soft-edged reflections paint wet-in-wet. I often combine both

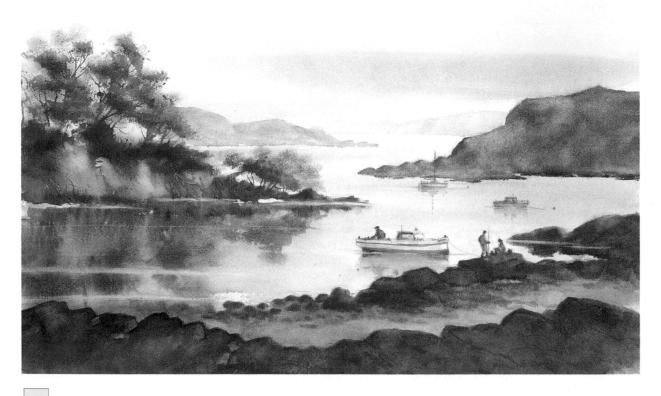

Time for a Drink

350 x 300 mm $(14 \times 12 \text{ in})$ A combination of hard and soft reflections have been used here. The reflections of the bushes were painted wet-in-wet and allowed to dry before I overpainted the crisper reflections of the fence posts and the huge tree trunk. The sparse foliage remaining on the trees is reflected loosely, wet-in-wet, because it is almost impossible to reproduce it all accurately.

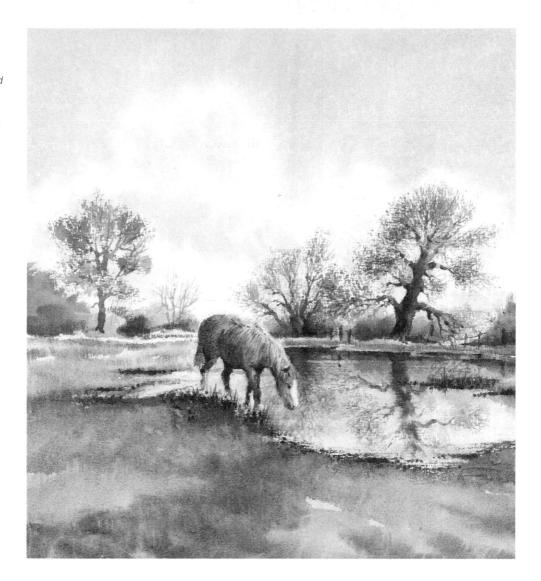

techniques, especially when painting tree reflections. The trunk and thicker branches can be painted wet-on-dry, but the random shapes of the foliage are best described wet-in-wet. There is no need to paint every stem or branch in the reflection.

If you find it difficult to work out how a reflection should look, hold a mirror up to the base of the object for an instant impression. You may also find it easier to turn your board upside down to paint in the reflection.

Do not confuse reflections with shadows, which can appear on the surface of the water when it is not ruffled by the wind. In clear, shallow water, shadows can also fall on the seabed or riverbed, in which case they follow the undulations on the underwater surface. In some instances – for example, a post standing in still water – the reflection, which will be hard-edged, will mirror the angle of the post, but the angle of any shadow will depend on the direction of the light. Reflections are always vertically aligned with the actual object, whereas shadows cast by an object are thrown onto the ground, or other objects nearby, in the opposite direction to the source of light. Remember that shadows will also follow the contours of the ground on which they fall.

Painting a River, Not a Road!

Whenever I paint a river or stream it looks more like a road than water. Sometimes it even appears to be running uphill! The colours look right, but that is about all. What can I do?

In the top diagram the river barely tapers, looks far too wide and is drawn at an obtuse angle with straight edges, so looks rather like a road.

The lower diagram shows a better approach with lots of short, uneven, but essentially horizontal, lines to form a ragged bank. The river leaves the frame at the side rather than at the bottom and narrows in the distance.

Many people paint a river or stream and forget to consider the perspective. If you paint the river or stream wide in the foreground and narrow as it meanders away into the distance it will look more realistic.

Another important point to remember is that riverbanks are seldom absolutely straight, so soften the lines indicating the banks by making the edges uneven to give a more natural appearance. Paint these edges in a fairly dark colour; this will emphasize the effect of the lighter colour of the water running between the banks.

If you are trying to convey still water, even on a narrow strip, always use horizontal brush strokes so that any gaps or overpainting will retain a horizontal impression. For moving water the brush strokes should follow the direction of the water's flow.

If you finish a painting and find the river or sea appears to run downhill, simply reposition the mount, making sure that the horizon is horizontal. If buildings also appear in the scene, ensure that the walls are vertical and do not tilt.

Stream Through the Trees

350 x 270 mm (14 x 11 in) This stream follows a vaguely similar route to the path, but because the edges are staggered and not straight it is clearly a meandering waterway. The effect is emphasized by the dark banks at the waterline, which contrast well with the light reflections of the sky on the water.

Painting Moving Water – Rivers and Waterfalls

When I paint moving water I cannot decide which direction the brush strokes should go to achieve the right effect. How can I paint water so that it really looks as if it is fast-running?

The Run

330 x 480 mm (13 x 19 in)
To suggest the fast-moving water I painted a light underwash of pale blue wet-in-wet, taking the brush strokes down the river to emphasize the movement. I left lots of white space to suggest the foam bubbling on the water.

We can learn something from photographers here. For a detailed, sharp image, they use a fast shutter speed to freeze the action. To achieve the same effect in a painting, you need to apply a strong mixture of paint to dry paper in rough streaks that suggest moving water.

However, if the photographer uses a slow shutter speed, the water looks blurred and even faster moving. You can create a similar effect by painting the water with a soft-edged look, using wet-in-wet techniques.

My method is to mix these techniques and paint a wet-in-wet light blue wash, with the brush strokes following the direction of the water, emphasizing its rise and fall. When this is dry I paint darker tones with a stronger, drier mix of blue-grey to accentuate the flow over the rocks. Highlights of flying spray can be picked out with a scalpel when the paint is dry or rubbed out with sandpaper.

Painting the Sea

Because I live by the sea and enjoy watching it, I would love to paint it in all its moods – especially when it is really rough and the waves are crashing over the rocks. What is the secret?

The Cove

320 x 450 mm (13 x 18 in) To capture the heavy sea and pounding surf I used a 25 mm (1 in) flat brush and a dry mix of paint, using short, upright, curving brush strokes to suggest the breakers. When painting the sea you need to plan the composition of your picture carefully. Use the white of the paper for the wave crests. This will provide the impact and sparkle necessary to capture the might and power of the waves to maximum effect. Simplification is the keynote – it is impossible to paint every wave, but it is

essential to include enough to show the movement of the water.

When I start to paint the sea, I apply a wet-in-wet underwash of Raw Sienna with a touch of Lemon Yellow, trying to avoid the areas that I have planned to leave as white paper. I make sure that there are no hard edges and I use dampened kitchen roll to pull out any paint that creeps into the larger white

areas. I allow this underwash to dry completely before damping the paper all over again with clean water and allowing the water to soak in.

Then I continue to paint the sky and water, selecting appropriate colours to suit the planned mood of the painting. To paint water effectively, ensure that your brush strokes follow the direction of the water flow, whether painting wetin-wet or wet-on-dry. Usually I establish the general structure wet-in-wet and, once this is established, I add the finer detail wet-on-dry. Remember that even waves follow the rules of perspective, so bear this in mind when painting each line of approaching waves. Breakers have light tops, which you can show by leaving white paper or by pulling them out with a damp piece of kitchen roll. For contrast, paint dark shadows beneath the wave crests.

Large crashing waves can be painted wet-in-wet to achieve a soft-edged effect. Spray can be added when the paper is

dry by using glasspaper or picking out small specks with a scalpel. As waves recede they leave wet areas on the sand that reflect the sky, so these areas need to be planned in advance and painted at the same time as the sky. As the sand dries out, the reflections fade and the warmer colours of the sand and shingle show through, except for the areas in shadow, which will have a cooler appearance. These can be overlaid with a pale blue wash.

I use the white of the paper to suggest the wave crests. Here I painted the areas in between the tops of the waves with Cobalt Blue, working wet-in-wet. When this had almost dried I darkened the underside of the wave crests with a darker mix, adding Ultramarine Blue and a touch of Alizarin Crimson. Where the colour bled into the white areas I pulled it out with a damp bristle brush and a piece of lightly dampened kitchen roll. I used slightly curving brush strokes to match the roll of the waves.

The Wave

260 x 350 mm $(10 \times 14 \text{ in})$ I painted the sky wetin-wet around the large wave shape. allowing space for the paint to bleed into the unpainted area. While the paper was still damp I painted the incoming waves with Cobalt Blue and a touch of Viridian using a medium round sable brush. I strengthened the underside of the wave crests, adding a touch of Ultramarine Blue and Burnt Sienna to produce a strong blue-grey. Final details were added with a similar colour when the paper was completely dry.

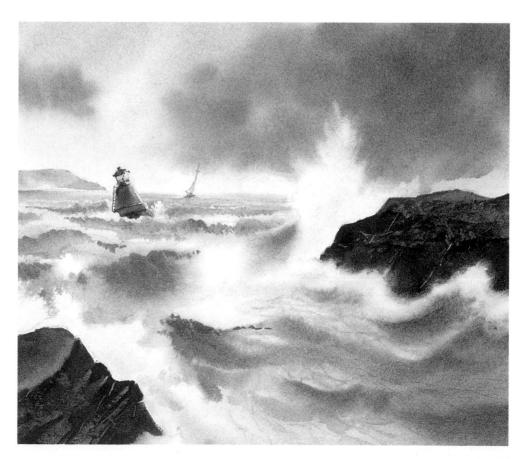

Painting Rocks That Look Solid

When I paint rocks they look more like bricks and I find it difficult to indicate their rough or smooth surface. How can I make rocks look solid and bring out the various textures?

Shape your brush strokes to match the shapes and bulk of the rocks you are painting. If you are painting small, rounded individual rocks or pebbles, a medium round brush can be dabbed onto the paper or used with a curved stroke to give a rounded appearance to large rocks. A heavy shadow on one side will give the rock more body; this can be painted wet-in-wet for a soft transition or wet-on-dry to define the shadow and any darker crevices more clearly.

Paint large squarish rocks using vertical strokes with a 25 mm (1 in) flat brush held at about 45 degrees and a dry mixture of paint.

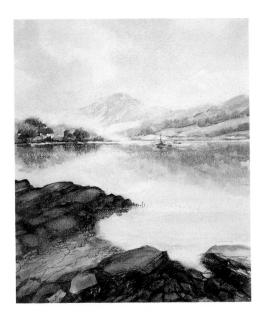

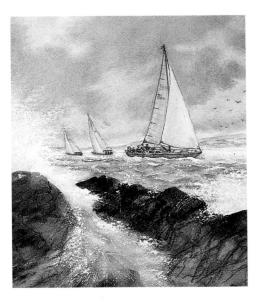

The Race (detail)
320 x 250 mm
(13 x 10 in)
The rocks were
painted using vertical
and angled strokes
with a 25 mm (1 in)
flat brush and a
strong mixture of
paint. As this dried

cracks and grooves were painted using a darker mix. When this had dried highlights were picked out with an old credit card. The fine spray was sanded out with glasspaper when the paper was dry.

I like to paint rocks wet-in-wet and overpaint them light to dark both wet-in-wet and wet-on-dry for variation. Use dry-brush technique to suggest texture, using a dry mixture with the brush held flat to the paper. Fine cracks or texture can be added when the early layers are dry using a rigger.

View from the Shore

760 x 560 mm (30 x 22 in) Most of the foreground rocks were painted using a large flat brush. The stronger directional outlines formed by the shadows between the rocks were painted with a mixture of Burnt Umber and Ultramarine Blue and fine detail was added using a rigger. When the paper was completely dry I glazed parts of the rock surfaces with a light wash of Lemon Yellow, repeating a colour used in the distant hills.

Painting Boats That Float

I always have trouble painting realistically shaped boats, especially those that are floating on the water. Why do mine sit on the surface rather than look as if they are floating?

If you have problems painting boats floating on the water, draw a complete boat to start with as if was sitting on top of the water. Then rub out the bottom of the hull with an eraser as if the water level was slowly rising. When it reaches a reasonable level, draw in a rough line to indicate the water level and your boat will now float gently on the waves.

One reason for boats looking unrealistic is that they are frequently poorly drawn. Simplify the process by drawing a starting shape that resembles a block, brick or shoebox and then imagine it partly submerged

and then imagine it partly submerged with the lower third under the water.
Unlike a box, a boat is rounded, so you need to draw the rounded shapes contained by the imaginary box.

Where the water touches the hull at the waterline, it produces a curved line, not a straight one, in the same way that a floating ball will produce a rounded line where it touches the water and displaces it.

To give a rounded look to the hull, paint a graduated wash from light to dark. If you paint the darker strip around the bottom (the anti-fouling) it may assume a triangular shape at each end and may almost disappear to nothing in the middle because the angle of the boat's bulging sides hide it from view. Avoid painting a dark outline all around the boat.

A box-like frame will also help you draw beached boats and avoid them looking like stranded whales.

The Red Boat
295 x 460 mm
(12 x 18 in)
The two foreground
boats were added to
create a focal point in
a pleasant, but bland

scene. The rigging was suggested with broken fine lines painted with a rigger. Use a ruler for these lines and the mast and boom if your hand is not steady, but avoid making them too precise. Remember when the tide recedes most of the boats will swing round and face in the same direction.

Features in the Landscape

Many people think of landscapes only in terms of broad, sweeping tracts of countryside, but there is much more to consider than hills, woodlands and fields. Wander off the beaten track and you will discover streams, rivers, bridges and buildings that offer painting opportunities in their own right and are all valuable for use as elements in broader compositions.

Chapel on the Hill

330 x 210 mm (13 x 8 in)
This imaginary scene is based on a small chapel I photographed in Majorca. Although this building is far larger than the original one, I wanted it to stand out on the skyline in the same way. The perspective is 'loosely accurate' and the scene was mostly painted with a size 8 medium round sable brush. The unusual treatment of the rocky slopes was achieved with a painting knife. I worked the knife into almost dry paint, producing the appropriate directional lines combined with flat areas of colour.

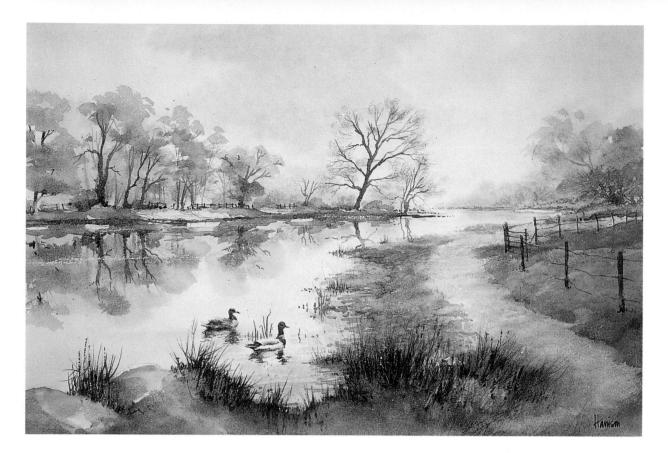

Canford River

350 x 530 mm (14 x 21 in)
The spring trees and their reflections make a pleasant backdrop to this calm river scene. These were painted wet-in-wet and wet-on-dry. The two ducks were actually spotted at a different stretch of the river and in different positions. They have been painted with a reasonable amount of detail so that

the eye is drawn to them.

Often, small details and areas of interest catch the eye – such as a cluster of flowers growing by a stile, a tiny shack with a rusty roof, or an old stone bridge straddling a meandering stream. Make a quick sketch or take a photograph to add to your reference material.

Drawing individual features

Practise painting these elements; it is surprising how frequently even simple subjects can cause problems. Bridges and buildings, in particular, are features that require careful thought at the initial drawing stage. Spend a little time investigating the rules of perspective; this will give you the confidence to be more adventurous in your choice of subject.

Keeping it loose

Often, it is the small details that make or mar a painting. It is all too easy to overwork a specific area, so even when you paint fairly detailed objects try to follow the maxim 'for looser work, use larger brushes'. Practise painting small objects with a brush that is, in theory, too large – you may find the results pleasantly agreeable. Nearly all painters seem to have trouble with the later stages of a painting, often including too much detail. Try and restrict detail to the main subject and you will find that the eye will travel to it automatically.

Fields, Foregrounds and Grassy Banks

When I paint rural scenes I find it difficult to depict fields or grassy banks in an interesting way. How can I bring out the undulations in the terrain and avoid them looking flat?

Dorset Farmhouse

350 x 480 mm (14 x 19 in) From this vantage point there is a wonderful view over undulating hills and fields. Lemon Yellow and Cobalt Blue were used in the early stages to achieve a cool fresh look. Then warmer greens were brushed in, mostly wet-in-wet, for the trees, adding Raw Sienna and Ultramarine Blue for variation. Note how the fields are graduated in tone here and there to show the humps and hollows in the ground. This effect is emphasized by the lines of hedges and trees running along their borders. Stronger, warmer tones were brushed into the foreground slopes wet-in-wet.

Even if fields are actually flat, there are still variations in colour, tone and texture depending, for instance, on the direction of the light source, whether there are any cast shadows, variations in the surface soil, or movement in grasses or crops caused by the wind. Most fields, however, have slopes and hollows and all these factors need to be taken into account in reproducing the scene as a painting. It is obviously not sufficient simply to paint a flat colour, so you need to vary the hues, textures and tones to suit the subject.

Start with a value sketch to show up the tonal variations. Graduated washes

Even in a quick pencil sketch, graduations of tone show the convex shape of some fields, while ragged lines suggest the texture of a ploughed area or a rough track. The variety of overlaid tones on the banks clearly indicates that the ground slopes.

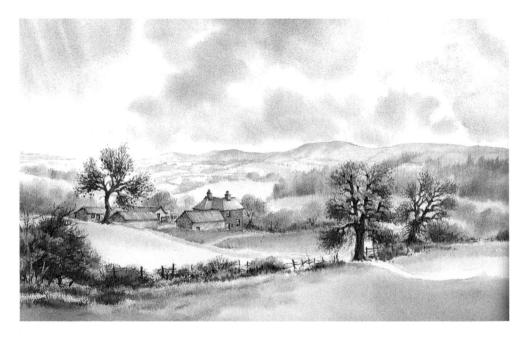

Road to the Hills

360 x 480 mm (14 x 19 in) Here, varied colours blended wet-in-wet over the distant hills suaaest subtle changes in the surface. Directional brush strokes used to paint the grassy banks have resulted in bands of blended colour that stress the angles and curves. The filtered light shining through the hedge on the left creates directional shadows that again help to describe the slope of the bank.

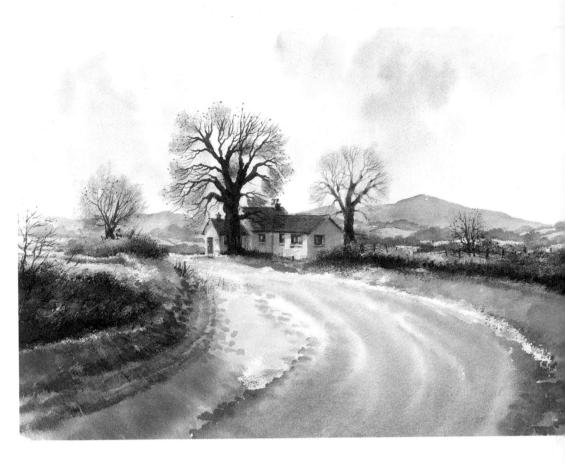

can be used to suggest undulations in the surface in the same way that graduated tone gives the impression of a curve on a cylindrical object. The lightest areas will be those closest to the light source or furthest in the distance. Even when working in one colour, dry brush and similar techniques can be used to show different surface textures, stones, rocks, and furrows, etc.

In your finished painting use graduated washes in the appropriate colour and tone to indicate the curvature of the terrain. Accentuate this effect by overpainting wet-in-wet with darker colour.

Another way to emphasize the humps and hollows of fields is to apply small areas of variable colour and blend them together on the paper wet-in-wet. Move the brush to match the slope of the land and do not worry if it misses a little here and there – the highlights will help to convey the variable nature of the terrain. When the paper is almost dry, use bold, sweeping brush strokes to

apply darker tones and let the colours blend into the previous layer of paint.

Allow the painting to dry completely, then add texture using dry brush technique, again following the line of the terrain. Shadows can be painted for added interest, but make sure the wash follows the undulations of the land.

Similar techniques can be used on roadside verges and riverbanks.

For added emphasis at the roadside or on a riverbank, paint spiky stems. Load the rigger with a strong mixture of Burnt Umber and Ultramarine Blue and hold it parallel to the upright edges of the paper just above the surface, holding the handle with the fingertips. Each time you press the bristles onto the paper surface they will deposit vertical lines of colour that resemble spiky grass or reeds. Vary their height and thickness to look really effective.

Painting Hedgerows That Look Real

I try to make my hedgerows look interesting, but the colours merge together and go muddy so that they look as solid as a brick wall. How can I paint hedges that are not so flat and lifeless?

The Hedgerow

350 x 490 mm (14 x 19½ in) A high summer sun produces a light top and dark shadows to the underside of this hedge, which also reduces in size as it becomes more distant. I built up the colours from light to dark, starting with Lemon Yellow; then, as this dried, I added Cobalt Blue and a touch of Raw Sienna and partially overpainted a mid green. Stronger greens were added each time the previous lavers were almost dry, some of the colour blending and some not, producing a good variation of hard and soft edges. Final detail was pulled out with a rigger brush.

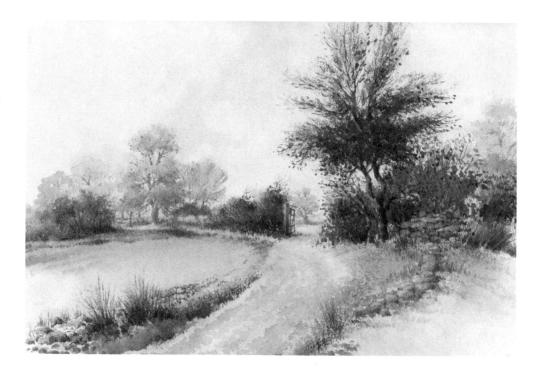

It is essential to vary the height and bulk of a hedge to prevent it looking like a flat surface. At the drawing stage make sure the top is not too level. Give the bottom of the hedge a ragged shape to suggest varying thickness.

Start painting the hedge by applying the lightest colour, probably a yellow-brown, and remember to leave a few gaps here and there so that it does not look too solid. With the heel of the bristles of a round brush or the corner of the bristles of a flat brush or hake, use a stippling motion to obtain a

random appearance and a rough edge along the top, or use dry-brush technique.

Build up the colours gradually, working from yellows to greens for summer hedges and yellows to browns and reds for autumn and winter hedges. Wait until each layer of colour is almost dry before applying the next one. Be patient and remember to make the hedge darker along the bottom where it is in shadow, keeping the colours varied. A few spiky branches and odd leaves shooting out of the top can be painted in with a rigger.

Painting Light Grasses Against Dark Undergrowth

I cannot work out how to paint light-coloured grasses so that they stand out against a background of dark undergrowth. Can you tell me how to do this without using opaque colour?

The answer is to paint the light area first and overpaint a darker colour for the undergrowth, creating a ragged edge that will suggest the stems and grasses. Start by painting the pale colour, using Lemon Yellow or Raw

I masked off some daisies, then painted a band of Lemon Yellow behind where I wanted both the light and dark grasses to be. While this was still wet, I blended in a pale wash of Cobalt Blue at the top.

Sienna, and extend it to cover the area where the darker undergrowth will be. Allow this to dry completely.

Then, using a a strong, drier mixture of the darker colour, say a medium green, paint in the darker area by pulling down streaks of colour over the top of the light area. Use a dry-brush technique to achieve a rough random edge. This creates the effect of having light stems on a dark background when, in fact, you have overpainted the dark gaps between the stems. Use a rigger to pull down spiky points from the dark colour into the top of the light area. To add interest scratch out a few highlights with a scalpel or palette knife and add darker stems and shadows with a rigger.

When the background wash was completely dry, I overpainted the light grasses so that they would stand out better, using a slightly stronger yellow mix. Then, adding a touch of Raw Sienna and Cobalt Blue, I darkened the base of the stems. When this was completely dry, I used a stronger mixture of the green colour and drybrushed this down over the tops of the grasses, leaving the

edges rough and not too straight. Using a rigger I extended the colour down in places between the light grassy stalks. When dry, I rubbed off the masking fluid and pulled out a few more stems with a scalpel.

Better Perspective

I have problems drawing and painting buildings accurately. I find the subject of perspective complicated and I get confused. How can I find a simple way to get the perspective right?

Many people have trouble with perspective and most problems start at the drawing stage. Although you are not aiming for technical perfection it is still helpful to start off with a drawing that is essentially accurate. Try and keep things simple. Decide the most attractive angle of the building, then choose a high or low-level view to suit the subject. Avoid side-on elevations; they can often look uninteresting. Think of the building as a cardboard box with both halves of the

lid lifted up at 45 degrees. In fact, if it helps, keep a box handy and use it for reference when drawing.

The main point to remember is that if a building is below eye level, then the line of the roof, eaves, windows and doors will run up towards imaginary vanishing points on the horizon. If it is above eye level, these lines will run down towards imaginary vanishing points on the horizon.

A simple method that I recommend may help to establish these basic principles firmly in your mind. You will

Preparing for the Trip

305 x 455 mm (12 x 18 in) Where a strong reflection is indicated it is important to position this correctly in relation to the building itself. At water level it will be a mirror image, but the shape changes as your viewpoint changes. In this painting the reflection shows more of the underside of the porch roof because our eye level is above the water. Regardless of viewpoint, reflections of vertical posts and any other upright feature will also be vertical.

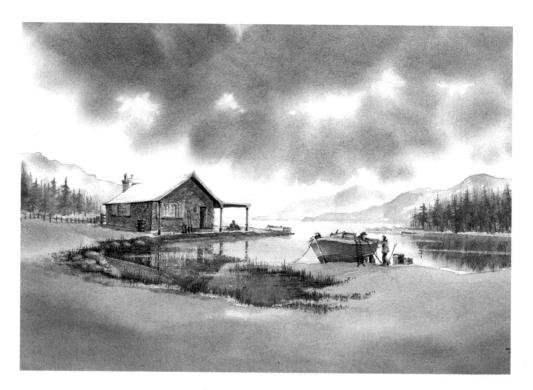

need a small piece of card or plastic and two lengths of string elastic each twice the width of your drawing board.

The card will need to be tall and narrow; the exact measurements will depend on the size of the painting that you intend to do. I use a piece of plastic about 15 cm (6 in) by 2.5 cm (1 in). Drill or pierce a hole about 6 mm (¼ in) from the top and bottom of the card or plastic. Thread one piece of elastic through the top hole, and the other through the bottom one, then tie all four ends together in a knot.

To use your perspective device, stretch the elastic around your drawing board with the knot at the back. If the elastic is too slack reposition the knot as required. Fix the elastic at each side with masking tape so that the ends are level with the horizon line in your drawing (these will be the vanishing points). You can then move the card up and down or from side to side to draw the vertical lines. The angle of the elastic will give you the correct sloping lines in perspective.

Hold the card in a vertical position to draw in upright lines. Remember, the walls of buildings are always vertical.

A simple means of working out perspective is to take two pieces of string elastic and thread them through holes in a piece of plastic or card. The four ends of the elastic are knotted

together and the elastic is then looped around the drawing board with the knot at the back. The elastic is then taped level with the horizon at the side of the board on the vanishing points.

The device enables you to draw vertical and sloping lines in correct perspective.

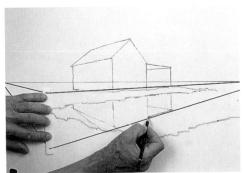

When the card is moved above the horizon line, the upper elastic can be lined up to show the correct angle for the line of the eaves. Use the same procedure for the lines of the ridge and windows.

When the card is moved below the horizon line the lower elastic can be lined up to show the correct angle for the reflection.

Painting Convincing Buildings

I am having difficulty in conveying the character of the cottage featured in my painting. How should I tackle this type of subject so that the buildings look authentic?

Bring buildings to life by painting a light underwash first that will show through the succeeding washes.

Graduate the colour on each wall from light to dark to give the building depth. Remember, too, that walls often reflect light and colours from objects nearby.

Paint the walls using single washes for each side of the building, varying the tone and adding shadows to suggest depth. My own preferred method is to paint the whole building in the same colour to start with, then overpaint a series of washes, each time leaving out one or more walls to produce varied strength of colour and tone on each as required. The roof is overpainted last. This is a way of overpainting that can also be used throughout other areas of your painting.

A typical fault is to paint the roof with an outline all the way around. It is sufficient to paint a slightly darker line along the top and bottom to emphasize the ridge tiles and the eaves. Even these lines are best painted roughly rather than precisely.

For a textured effect on walls and roof, allow the washes to dry, then use dry-brush technique. To avoid surplus paint falling onto the surrounding areas, hold a straight-edged piece of paper down the side of the wall or roof you wish to paint and drag the brush across the plain paper onto the

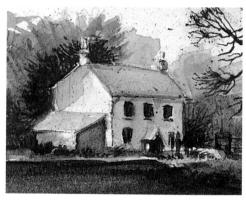

The windows in this painting have been painted far too dark and look like holes in the brickwork. This can be remedied by

damping the dark areas, allowing the water to soak in, then gently teasing out the colour with a stiff bristle brush.

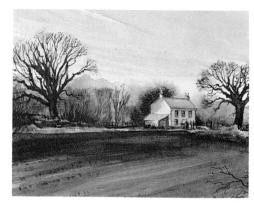

Ripley
240 x 340 mm
(9½ x 13½ in)
Once the window
areas are dry, they can
be repainted using a
pale blue wash for the
glass panes, leaving a
lighter patch at the

top where the upper part reflects the light. A darker shadow can be painted at the top and side furthest away to suggest the recess in the wall.

After the Snow

360 x 450 mm (14 x 18 in) A friend's photo of remote farm buildings in the Yorkshire Dales inspired me to imagine the scene after a fall of snow. I used the white of the paper to suggest the snow and used a restricted palette to achieve a harmonious colour scheme. The buildings were painted with Raw Sienna and when this dried I overpainted in layers, adding various amounts of Cadmium Red, Cobalt Blue and Ultramarine Blue. The only other colour used was Burnt Sienna, which was mixed with Ultramarine Blue to produce the strong dark touches used for emphasis. Dry-brush technique was used for texture.

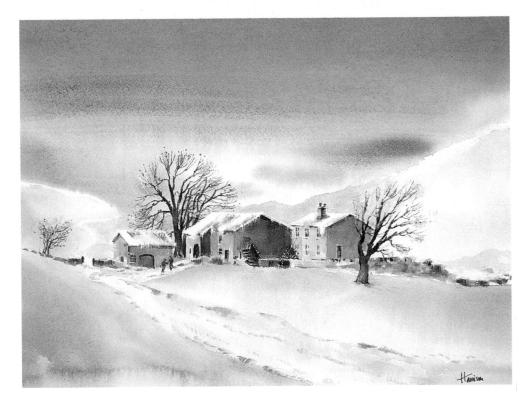

required area. This ensures that you retain a clean edge. Quite often even the darkest roof shows as the lightest tone because its slope reflects the light in the sky, so it can be left unpainted or given a light wash of pale blue-grey. This is something to consider at the planning stage.

Avoid painting the windows on your buildings so dark that they look like black holes. Windows should be suggested, not painted in great detail. For the window recess, leave unpainted

rectangles on early washes – on the first wash if you want a white area left, or the second wash if you prefer a coloured opening. Then indicate the windows simply with a touch of pale blue-grey – not too dark. This should be lighter towards the top where the sky is reflected, but dark at the very top and down one side to indicate the shadow where the window fits into a recess in the brickwork or stonework.

The Boathouse

330 x 520mm (13 x 21 in)
Even a fairly modern building can be made to look interesting given the right surroundings. The backlighting adds to the overall effect, producing shadows that run towards the viewer and help to pull the viewer's eye into this busy scene.

The low viewpoint makes the building and the hanging boat stand out more strongly against their backgrounds. It also increases the angle of the roof on the building, giving it a more dynamic appearance. Correct perspective is important here.

Stonework, Walls and Texture

I find it quite difficult to get the effect of rough stone for walls and old buildings. I do not seem to be able to get the colours or the texture of the stone right. What am I doing wrong?

Morden Church

330 x 380 mm (13 x 15 in) Although in shadow, this stone wall has a lot of shading and texture, which pales as it recedes down the lane. The mixture of colours was built up in layers light to dark, producing blue, brown and violetcoloured stones with detail added with a rigger when the surface was dry.

The answer is to build up the colours in easy steps. Work from light to dark, mostly wet-in-wet to start with to give some blending of colour. Then, as this dries out, overpaint vague stone shapes in darker tones wet-on-dry. If some of this painting is done before the previous layer is completely dry, random blending will occur in places, which helps to add realism.

When this is dry, paint more definite stone shapes in clusters rather than over the whole area and use fine lines to emphasize individual stones in places. To complete the effect darker stones can be added here and there and dry-brush used on some of the stones to suggest the roughness of the surface.

For dry-stone walls ensure that the line of stones at the top does not look too level and insert strong shadows to emphasize where some stones have been laid upright.

Above: Whether you are painting walls, stonework, rocks or wood the techniques are similar. Work from light to dark, allowing each layer of paint almost to dry before overpainting the next layer to produce soft and hard edges. When completely dry,

use dry-brush techniques with a stronger, drier mixture of paint to suggest texture. On wood, as on rocks, a rigger can be used with a dark colour to paint holes, grooves or cracks.

Painting Bridges That Look Real

My bridges always look lop-sided and I never seem to get their reflections looking right. Is there an easy way to achieve an accurate shape so that the bridge looks more realistic?

The Old Bridge 320 x 300 mm (13 x 12 in) This small bridge was

drawn carefully and, despite the unusual angle, it is clear that the arch is roughly central and symmetrical in shape. Always draw the

bridge first before

deciding on the position of the banks, unless the bridge is a long way distant. The dark arch usually has reflected light bouncing on to the lower part from the water, so I have graduated the colour to take account of this. The stonework was

painted wet-in-wet to start with, then as it dried the vague shapes of the stones were made slightly more distinct. Some rough outlines were added with a rigger. It is essential to draw a few simple guidelines to ensure the bridge is at the correct angle and the perspective is accurate. It helps to think of the bridge as a large block or brick laid on its side with a round or oval hole (or two) cut in it. If you moved this around you would see that the angle of the viewpoint determines how much you see of the arch.

Use equal squares or rectangles as guidelines to ensure accurate bridge shapes and their reflections. Overlay a circle (or oval) to form the arch. If the arch is straight at the sides, still start with a circle and adjust the shape later. Note that the shapes of the bridge, its arch and its reflection are symmetrical.

If you move to the side the bridge becomes foreshortened – the line of the top of the bridge slopes up or down depending on your viewpoint and the circle of the arch becomes more oval in shape. Use the guidelines in perspective to draw the new shapes.

Including Flowers In Your Landscape

For many years I have concentrated on painting flowers, but I have been dabbling at landscapes recently. How can I introduce flowers into my landscapes without the scene looking forced?

If flowers are just an adornment to the main subject, they can be introduced into the foreground to lead the viewer's eye into a painting or in the mid-distance to liven up grassy banks and fields. A low-level view can be helpful and can often look quite dramatic.

If the flowers are to be the dominant feature in the picture, they need to be painted reasonably large in the foreground, with the background taking second place. By making the background area less detailed and painted quite loosely as if it is out of focus it will enhance your blooms rather than distracting the viewer. Paint the background wet-in-wet to achieve a 'soft' look. Try to paint light flowers against a dark landscape or dark flowers against a light-toned background.

For added interest, introduce extra features into the background such as a bridge, a building, a winding lane or river, for example, but avoid making them too prominent. For more variety in the foreground it can be helpful to home in on a small area where there is a stile, wall or fence or even farm implements that relate to the background scene.

Westfield Farm

345 x 525 mm (14 x 21 in) This scene was a short distance from our holiday cottage and I only had to find a gap in the hedgerow to paint it. In this case the flowers play a secondary role, but they help to lead the eye into the picture. Note the diminishing size of the daisies, which, added to the lack of detail in the stubble field, adds to the feeling of distance. The warmer, stronger colours used in the foreground also help this illusion.

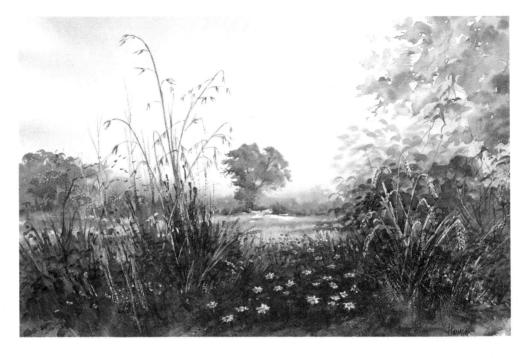

In the Red

470 x 360 mm (19 x 14 in) The diminishing size and tones of the poppies and the vague shapes and pale colours of the distant trees help to create the impression of depth. After applying a Lemon Yellow underwash, I painted the poppy heads wet-in-wet to keep them loose, overpainting darker shades of red as the surface of the paper dried to produce hard and soft edges. When dry, I used vertical brush strokes and a dry yellowgreen mixture to paint the stems and grasses.Where neccessary, this dark green colour painted wet-on-dry provided crisp edges to the poppy petals.

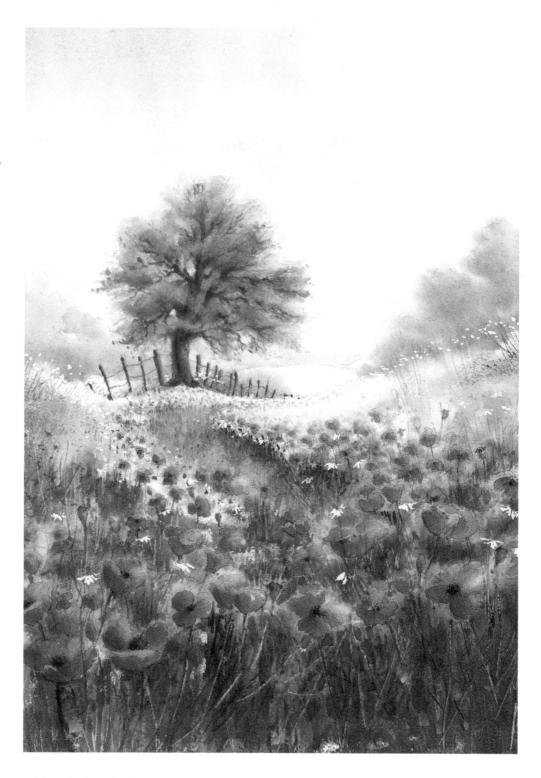

The choice of colours is important in this type of subject, which works well if the flowers are part of a scene that is mainly painted in harmonious colours from the same side of the colour wheel. Alternatively, surrounding blooms with complementary colours (such as red flowers in front of green fields as above)

can produce a more dramatic effect. If the blooms are to dominate the painting vary their shapes, sizes and tonal values so that they contrast with each other. If they are distant and merely enhance the scene you may find using pure body colour – for example small dots of white or yellow – helpful.

Figures, Animals and Birds

Morning Light

460 x 320 mm (18 x 13 in)
This is a scene I often see at the end of my garden. I have arranged the deer to form an interesting group varying in size and position. To add to the atmosphere I kept the distant trees pale and indistinct, using Lemon Yellow and Cobalt Blue with a touch of Cadmium Red to neutralize the colours. When dry, I overpainted the more substantial nearer trees and foliage in warmer, darker tones to add to the backlit effect.

New Shoes for Lancer

350 x 450 mm (14 x 18 in)
When the farrier calls on my neighbour
Mike, it reminds me of a bygone age.
The horse barely moves, making it
easy to capture in paint, and a small
natural grouping like this makes an
ideal subject. The only adjustment
needed to this scene was to move the
anvil closer to the action and to play
down the strong colours of the
background so that attention is
concentrated on the main subject.

Many painters never experience the full pleasure of painting in watercolour because they paint only one type of subject, such as landscapes or flowers. They often avoid painting other subjects because they regard them as difficult, so they miss out on a lot of pleasure (as well as pain) and fail to realize that including other elements in their preferred subject invariably enhances the composition and adds interest and scale.

Planning the arrangement

Of course, figures, animals and birds make excellent subjects in their own right, but if they are used merely as enhancements in a landscape or seascape, it is sensible to include them as an integral part of the design from the outset. So their size, shape, tonal value and quantity require careful consideration. Arrange them in natural groups – it is surprising how often you see isolated creatures or characters dotted aimlessly around a painting. Variety is the keynote; make sure these elements are different in size, colour and texture.

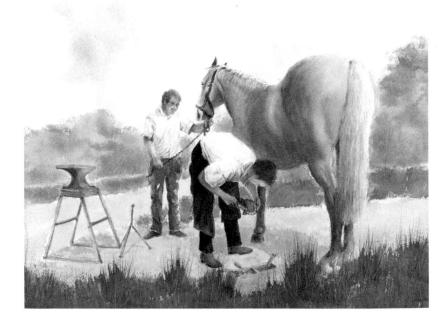

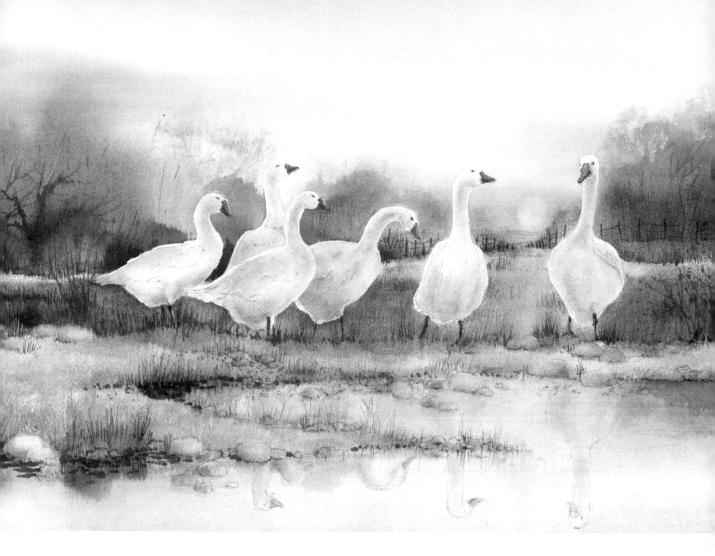

Follow the Leader

360 x 500 mm (14 x 20 in)
Geese always make good subjects
and arranging them in random fashion
in a line is typical of how they follow
each other about. In this painting I
used the white of the paper for the
geese, painting the background round
them to form the white shapes, then
adding shading to give them form. The
colours round the setting sun match
the shading on the geese and give
unity to the scene.

Natural poses

It is also important to create a design that includes your characters in natural poses or, preferably, in action. Scarecrows or statues are less dynamic than moving people; if people or animals are captured in the throes of natural activity, they are usually easier to paint and are sure to look more realistic. These added elements can often be painted over during the preliminary washes, especially if they are to be painted in strong colours and tones later.

Study the people or animals around you – observe how they move, and how the changing light casts shadows in the folds of clothing or on facial features, emphasizing shape and form. Notice how people stand and walk. Look at yourself in the mirror. You are a three-dimensional object, so work out how to suggest this on a flat piece of paper and try it out.

Inserting Figures to Enhance a Composition

I am always nervous of adding figures to a painting and find it difficult to get them in proportion. How can I paint them the right size and shape and be sure that they will look natural?

Inserting figures adds both scale and interest to a painting, but it is all too easy to ruin a picture with

badly placed, or out of proportion figures. That is why it is so important to decide their size and position at the planning stage and ensure that their inclusion will enhance the composition.

First check that figures are the correct height in relation to their position

within the scene and that they follow the rules of perspective. In principle, objects appear smaller as they recede into the distance, but it is important to relate the size of the different elements to each other so that people do not suddenly appear taller than trees or

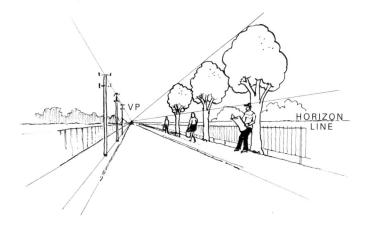

houses, for example.

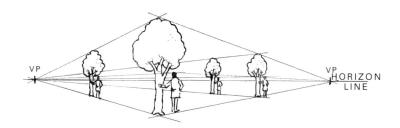

Left: For broad scenes such as landscapes or street scenes where figures are arranged randomly, draw a horizon line (at eye level) with a vanishing point in position at each side (this is two-point perspective). Guidelines from the vanishing points can

be extended above or below the horizon to indicate the height of your figures or other objects in your sketch.

Start by drawing the nearest figure to you (which will probably be the largest) and use this one as a guide to the size of the others.

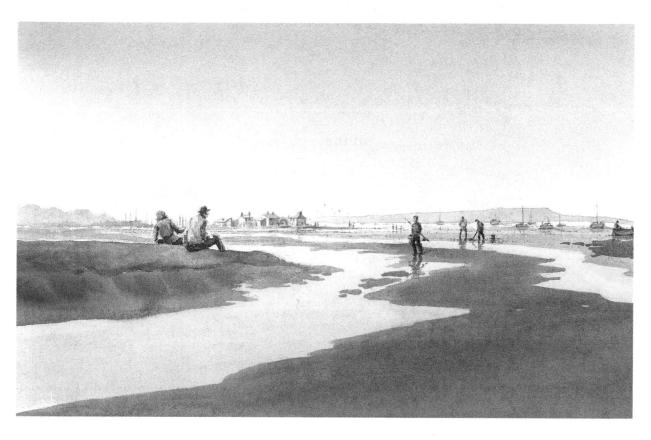

Low Tide at Mudeford

300 x 540 mm (12 x 22 in) Coastal areas offer rugged terrain, wonderful skies, beaches and sea as well as the human element in the form of local fishermen and visitors. Where figures are randomly placed make sure they are all painted in proportion. The fact that they are all there for a purpose helps to make the painting believable, although this early morning scene was originally devoid of humanity.

If you are not good at drawing, use lightly drawn box shapes and cylinders as aids in achieving the right proportions. Alternatively, draw simple stick people to start with, arranging the lines to show the angles of the shoulders, hips and the spine. Then complete the shapes using these as guidelines. Avoid making heads too large – on average they are only about one eighth of the total height of the body and roughly a third of the width of the shoulders. If you paint them even smaller they will probably look fine.

Paint the figures in loosely, using a medium size brush and avoiding too much detail. I usually paint the complete figure in a pale flesh colour, then paint the clothes over the top as this dries out, working wet-in-wet at first,

then wet-on-dry, to put in the small touches that suggest folds or shadows on the garments. A little shading here and there with a darker colour can bring the figures to life.

Omit the feet, unless the figures are very large; the viewer will imagine them. Should you later decide to add figures that are unplanned, check to see if they fit by drawing them on a transparent overlay and hold this over the painting to confirm the proportions.

If you find it difficult to remember the position of a particular character, stand in front of a mirror and sketch yourself in a similar pose. Use a second mirror for the back view. If you have a camera or camcorder, photograph or film yourself to provide any reference you need.

People As Main Subjects

Although I often paint people from photographs, I would prefer to paint from life, but I find it hard to capture a true likeness. How should I proceed?

The Art Class

320 x 520 mm $(13 \times 21 \text{ in})$ Painting a captive audience can be done without fuss, and an art class is an ideal subject with a varied range of people to select. Paint just one or two of the class if time is limited, but look for interesting characters and poses. It is not necessary to include much detail as long as you capture the mood of studied concentration or. more usually, lighthearted amusement.

If you want to paint figures as main subjects, it is better to capture them in action (even if they are only using the telephone or brushing their hair) rather than posing them artificially. People at work and play make particularly interesting subjects because they are in their natural environment, which puts them at ease and makes for a more successful painting. The paraphernalia attached to their pastime or occupation can be in evidence, which adds to the feeling of realism.

If you chat to people about your ideas for painting them, you will find that

most are only too pleased to help and will probably come up with useful suggestions themselves. Because of the time factor it can be a problem to paint in these situations and an easy solution is to produce pencil sketches that give you the visual information you need. You can then produce the finished work back in the studio where you can play around with it at leisure.

Too often people worry about capturing an almost photographic likeness when all that is needed is a pose or expression that is typical of the subject and will make them instantly recognizable. Most of us have little

Looking for Wild Flowers

320 x 190 mm (13 x 7½ in) Isolatina figures against a cluttered background is important. Here, the light hair of the taller lady shows well against the dark background hedge. The distant arch helps to keep the viewer's eye within the frame. A pointing figure or stick is always a good ploy to attract the eye because it is human nature to look where it is pointing.

quirks that can be brought out to good effect in a painting.

Painting groups of people is more difficult because you can hardly position them all as you wish. Practise making very quick pencil sketches to capture the essential poses that people adopt. You can do this unobtrusively and the drawings can be quite rough.

Often a quick sketch makes an excellent basis for a painting. In working quickly you are obliged to pick out only the essential points and this

tends to result in looser and fresher work. In cases where sketching is not practical for reasons of time or because of the fast-moving nature of the subject, the only real option is to take photographs for reference. Take lots of information shots from various angles and try and acquire a few close-ups that will help when painting the faces. Experiment to find the direction of light that highlights the main features in the subject and best captures the atmosphere of the scene.

Including Animals in the Landscape

I would like to include animals in my landscapes, but I cannot seem to position them so that they look convincing. How can I draw and paint them with more confidence?

draw animals on location, take photos or video footage as reference. When you are back home, use these images to establish the ideal arrangement for your picture and make a number of planning sketches as a guide. Remember, you can add or take away or reposition the animals to suit your design.

It is important to think about your

If you find it difficult to

It is important to think about your placing of the animals from the beginning; if they are placed around a painting in a haphazard manner as an afterthought they will look totally unnatural. Plan your composition carefully and place the animals in believable positions (bearing in mind

the basic rules of perspective) in the same way that you add figures to a landscape. It is preferable to arrange them in groups, with some overlapping and one or more single ones for balance and variation. Try and vary the colours, too, using the standard technique of stronger, warmer colours in the foreground and paler, cooler colours for animals in the distance.

It is usually best if animals near the edge of the painting are positioned so that they are looking into the picture rather than out as this encourages the viewer's eye to move into the scene. The shapes of most animals can be simplified to make drawing them easier, so use box shapes, rectangles or tubes as

Rounding-up Time

340 x 520 mm $(13\frac{1}{2} \times 21 \text{ in})$ Looking over a farm gate provided the idea for this painting. The sheep seemed to be everywhere and the background mist made the scene distinctive, so I took a quick photo. I added the farmer and his dog to enhance the composition, but tried to reproduce the yellowy-grey haze out of which the sheep appeared. It is pointless in a scene like this to attempt to paint the animals accurately, so I have suggested them as simply as possible to capture the essence of the scene.

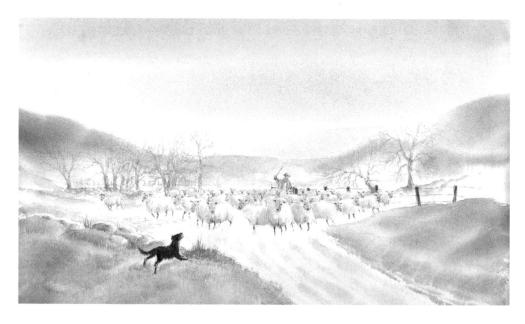

Refreshment Time

410 x 350 mm
(16 x 14 in)
The variation of size, colour and position of this grouping appears natural and this is what you should aim for.
Overlapping some of the animals might have been better still.
The reflections have been painted vaguely, wet-in-wet, to avoid distracting the viewer.

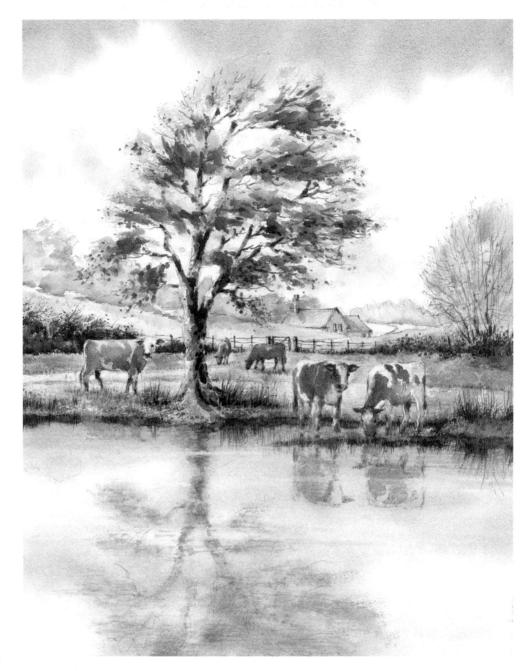

Quick sketches in pencil or colour can come in handy as reference for a finished painting. Carry a pad and pencil with you in the countryside or take your camera. Watch out for interesting poses, even in animals, because they all have their own ways of moving or standing. Make sure the heads are in proportion and, as with drawing figures, avoid making them too large. Paint them with a large brush to keep them loose.

guidelines in the early planning stages. Remember that the feet of cows, sheep and horses are usually hidden in grass, so they appear shorter than they actually are.

When painting an animal, do it in easy stages rather than trying to paint it with a single application of colour. I use a similar technique as for painting figures – painting a pale underwash of Raw Sienna (even on white animals) with a medium round brush, then building up the colouring and shaded

areas in easy stages, working wet-in-wet to start with to suggest the general form and then painting stronger shading and fine detail wet-on-dry.

Capturing Moving Creatures Outdoors

I find it hard to paint animals, and birds in particular, because it is difficult to get close to them. I have tried photographing them, but they are just too quick to focus on. What is the answer?

Happy Landings

350 x 510 mm (14 x 20 in) Soft shades of Lemon Yellow, French Vermilion and Cobalt Blue were used to produce the background to this restful scene in which the variety of wheeling gulls contrasts well with the still water and anchored boats. Despite the speed at which birds fly, it is possible to capture some of them in focus as reference if you photograph them in a flock. Make sure you vary their sizes, shapes and positions in your painting. I allowed the graduated background wash of light yellow to dry completely, then masked off the sail, the rims around the dinghies and some of the larger gulls so that I could paint the sky and water with complete freedom.

The main problem in painting living creatures is that they do not stand still for very long, so acquiring reference material can be quite hard.

Whenever you are on holiday or out for a country walk, keep a sketch book or camera handy because a subject can appear when you least expect it. A farm visit always opens up possibilities and a walk by the river is sure to be fruitful. Fortunately, floating subjects like ducks or swans tend to move fairly slowly. If you cannot get close to a subject, take photographic transparencies instead of

prints, then you can always project the image much larger to see more detail.

A single-lens reflex camera fitted with a zoom lens is a useful item to carry with you because you can see the same image that will appear in the photograph through the viewfinder, allowing you to frame the subject well and record detail without moving closer. A zoom compact camera is an easier-to-carry alternative. Use a fast film – for example, either 200 or 400 ASA, which will help to freeze the action.

To help you photograph the birds in your area you may care to copy a simple

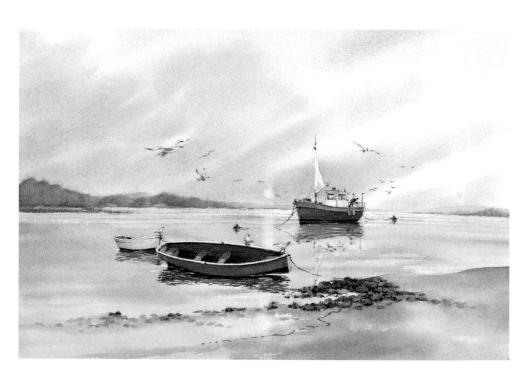

Take an interesting branch and tack it close to the top of the support pole and onto the edge of the platform of your bird table. Birds will alight on both the branch and the table.

Branch Meeting

330 x 270 mm (13 x 11 in) I use transparency film to photograph the feeding birds and project the slides onto a large white card for easy reference. To make birds stand out, keep the background out of focus by painting it wet-in-wet and blending the colours on the paper. When arranging birds in a picture try to make an interesting

cluster and paint them fairly loose, otherwise they can look as if they are stuffed. You do not need to follow your photograph too closely. To give the impression of moving wings as a bird comes in to land, paint it wetin-wet and the softness of the edges will give the look of movement.

idea that I have used at home. Within sight of a window, I erected a bird table and tacked a leafless branch from a lilac tree near the top of the supporting pole and to the edge of the shelf so that it projected above the shelf. This helps to disguise the bird table as a dead tree and makes it more attractive and inviting for birds.

With the camera on a tripod to keep it steady, I pre-focus my camera on the platform or branch and photograph the birds as they land for food. When they alight on the branch, in close-up they appear to be on a tree in the garden, which makes an excellent reference picture. If you prefer to sketch birds, it is still likely to be easier in this situation because they will keep coming back for more food.

When painting birds, build up the colours gradually. Use a medium round brush, painting wet-in-wet to start with, blending the colour on the paper to show the subtle changes in plumage. Paint the hard-edged detail wet-on-dry with a finer brush, emphasizing the directional lines that show how the feathers lay.

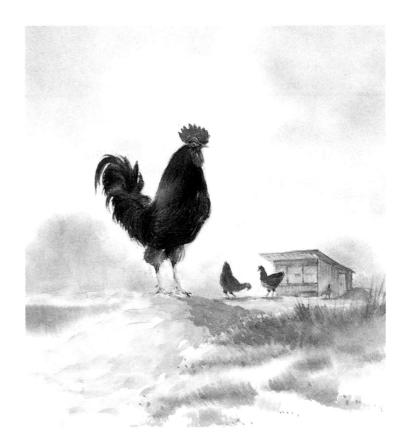

Lord of the Manor 350 x 300 mm (14 x 12 in) Once again a low vantage point highlights the strutting rooster in all his finery. The warm

mixture of colours

was blended on the paper wet-in-wet, using Lemon Yellow, Raw Sienna, Burnt Sienna, Burnt Umber and Ultramarine Blue. As this dried out, stronger colour was overpainted with

more directional brush strokes to create the feathery appearance. Final details were painted with a rigger when the paper was almost dry.

Finishing Touches

Overworking your painting - is there a cure?

Most of us are guilty of overworking our paintings and not knowing when to leave well alone. Cure yourself by imposing a limit to the time you need to paint a scene. Try a painting in, say, 15 or 30 minutes, one hour or two. Then do the same painting at your normal speed and compare the difference. The exercise will probably be an eye-opener.

Saving your painting when disaster strikes

When you hit a problem in the middle of a painting, avoid dabbing away with a tissue and try not to panic. Wait for it to dry completely, then dampen the offending area with clean water and allow it to soak in until the gloss has gone off the surface. Then tease out excess colour with a stiff bristle brush or gently work the bristles into any hard edges to soften them. Clean the brush on a damp piece of kitchen roll and add a little clean water as you go to retain the surface dampness. When nearly dry, freshen up the colour by applying more paint.

When your painting is a washout

Before rejecting a poor painting, try washing it completely under the tap and gently agitating the dried paint with a stiff bristle brush. Be careful not to damage the paper surface. Clip the paper to a backing board and use the pale ghostly image of your first attempt as the basis for a new try.

Creative masking and cropping

If there is a problem in one area of your painting that cannot be resolved by reworking it, astute cropping may be the only answer. This may even mean changing the format from landscape to portrait. Look through some of your finished paintings and try it.

'Rome was not built in a day'

If you are new to painting, do not expect immediate results unless you have a background in art or graphics, so do not take it too seriously. The only damage you can do, apart from a bruised ego, is to spoil a piece of paper, so relax and try out different ideas and enjoy yourself. By all means study books and video tapes and visit galleries and exhibitions, but ignore the pompous amateur (or, in some cases, professional) experts who insist you do things their way. Listen politely and make up your own mind. If you are pleased with what you produce, that is all that matters. I hope that after reading this book you will be on the right track. Happy painting!

Index

Page numbers in *italics* refer to illustrations and captions.

aerial perspective 44
animals 51, 84-5, 90-1
Milking Time 6
Morning Light 84
New Shoes for Lancer 84
Refreshment Time 91
Rounding-up Time 90
autumn 22, 27, 29, 50, 51, 74

backlighting 79, 84 birds 84, 85, 92-3 Branch Meeting 93 Follow the Leader 85 Happy Landings 92 Lord of the Manor 93 boats 7, 13, 17, 18, 20, 69 bridges 61, 71, 81 The Old Bridge 81 brushes 7, 8-9, 9, 11, 30, 40 bristle 9, 37, 45, 67, 78, 94 flat 8, 11, 11, 44, 46, 58, 68, 68, 74 hake 8, 33, 49, 51, 60, 74 rigger 9, 11, 68, 68, 69, 74, 74, 75, 75, 80, 81, 93 sable 9, 9, 67 squirrel 8, 50 for trees 50-1, 50, 57 brushwork 11 for birds 93 for landscapes 47, 70, 73, 73, 74, 83 for looser work 11, 71, 91

for mountains 44, 45

for rocks 68, 68

for snow 49

for skies 19, 34, 49

for trees 50-1, 50

After the Snow 79

The Boathouse 79

Ripley 78

for water 60, 64, 65, 66, 67, 67 buildings 17, 64, 71, 76-7, 78-9

'cauliflowers' (back runs) 37, 39 clouds 23, 34, 35, 36-7, 36, 39, 40-1, 40 dabbed out 38 cockling, of paper 10 colour 19, 22-31, 51 basic palette 23 colour wheel 24, 83 cool 7, 20, 22-3, 24, 26-7, 26, 51,90 lightening of when dry 40, 40 mixing hues 25, 28-9 muddy 28-9, 53 neutral 25, 26, 34, 35, 45, 51, warm 20, 21, 22-3, 22, 24, 27, 27, 35, 44, 46, 47, 51, 56, 56, 82, 90, 93 Autumn Hedgerow 29 Entering Harbour 23 Farmhouse at Ripley 22 Harvest Time 27 The Lake in Winter 26 Maine Coast 31 Summer Day 28 composition 13, 13, 14-15, 16, 42, The Lone Fisherman 14 Porlock Weir 13 cropping 94

depth 20, 21, 34, 44, 46, 57, 60, 83

The Estuary 21
details 71
distance 20, 44, 46-7, 56, 56, 82

Dusk on the Loch 47
dry-brush techniques 50, 68, 73, 74, 75, 78-9, 79, 80, 80

edges crisp 39, 44, 44, 47, 48, 61, 61, 62, 83 hard 39, 44-5, 63, 83, 93 soft 39, 44-5, 58, 62, 62, 63, 63, 83, 93

fields and grassy banks 72-3, 82 figures 17, 17, 84-5, 86-9 The Art Class 88 Looking for Wild Flowers 89 Low Tide at Mudeford 87
Milking Time 6
flowers 82-3
Clematis 6
In the Red 83
Westfield Farm 82
focal point 7, 14, 15, 15, 17, 69
Summer Walk 17
foregrounds 20, 21, 56-7, 82, 82, 90
format 13, 19, 94

glasspaper 8, 31, 58, 67, 68 graduated washes 26, 34, 35, 35, 47, 58, 69, 72-3 grasses 75

hedgerows 29, 74

The Hedgerow 74

hills and mountains 42-9

Château Chillon 45

Dusk on the Loch 47

Evening Calm 43

Swiss Valley 42

Welsh Valley 44

horizon 15, 47

lakes 45, 61, 62, 62
landscape features 70-83
Canford River 71
Chapel on the Hill 70
Dorset Farmhouse 72
The Hedgerow 74
Morden Church 80
Preparing for the Trip 76
Road to the Hills 73
Summer Walk 17
see also bridges; buildings;
flowers

masking (cropping) 16, 16
masking (masking fluid) 40, 48,
55, 57, 59, 75, 92
mist 45
mood 18-19
Kenyan Vigil 19
Light Through Clouds 18
movement
of living creatures 92, 93
of water 64, 65, 65, 66

overpainting 27, 35, 35, 41, 48, 73, 75, 75, 78 overworking a painting 94 painting knife 9, 59, 59, 70 paints 9 palette knife 21, 75 palettes (plastic tray) 9, 24, 24, 31 paper 8, 10, 31 cockling 10 white (unpainted) areas for animals and birds 51, 85 for clouds 23, 38, 38 for snow 27, 42, 48-9, 48, 79 for trees 59, 59 for water 31, 66, 67, 67 pencils, coloured 15 perspective 64, 67, 70, 71, 76-7, 79, 81, 86, 86 Preparing for the Trip 76 photographs, for reference 12, 17, 71, 89, 90, 90, 91, 92-3, 93 planning stage 7, 7, 13, 42, 66, 67, 79, 84, 86 problems 94 rain 41 reference material 12 reflections 61, 61, 62-3, 76, 77, 81, 81, 91 The Lake 7 rivers and streams 61, 64, 64, 71 rocks 11, 68 sandpaper 65

sandpaper 65
scale, sense of 6, 17
scalpels 9, 65, 67, 75, 75
sea 23, 60-1, 66-7
seasons 12, 26-7, 51
shadows 23, 28, 48, 49, 63, 67, 68, 79
sketches 12, 13, 14, 14-15, 16, 46, 71, 88, 89, 90, 91, 92, 93
tonal value 20, 20, 21, 21, 48, 49, 56, 72
transferring to larger paper 16
skies 32-41, 47, 49
Cottage at Horton 33
Eilean Donan 39
End of the Day 35

Feluccas on the Nile 32 The Good Old Days 37 Mudeford Sunset 35 Snow, Morden Church 34 Storm Brewing 41 Tree at Bulbury Woods 40 snow 27, 34, 42, 48-9, 58, 79 Icy Morning 48 Sundown 49 spring scenes 51, 51, 71, 91 stonework and walls 80, 80, 81 subjects 12-17 summer scenes 27, 51, 52-3, 58, 74, 74 Summer Day 28 sunsets 35 Mudeford Sunset 35

texture 68, 72, 72, 73, 78, 79, 80, three-dimensional effects 19, 43, 54-5 timing 7, 31, 33, 40-1, 56, 59 tone and tonal contrast 13, 19, 20, 43, 47, 72, 72 trees 17, 40, 50-9 foliage 52-3 in reflections 26, 27, 63 trunks 15, 51 The Backwoods 56 Bluebell Woods 57 Peace 55 Spring Morning 51 Through the Pines 50 Winter 58

underpainting (underwash) 27, 35

variety 15, 15, 72, 83, 84 in colour 32-3, 43 in shapes 15, 42 viewpoints 13, 37, 62, 76, 76, 79, 81, 82, 93

washing a painting 94
water scenes 26-7, 60-9
The Cove 66
The Estuary 21
The Fishing Trip 62
The Lake 7
Low Tide at Lyme Regis 60

Maine Coast 31 Morning Reflections 61 The Race 68 The Red Boat 69 The Run 65 Sailing 10 Stream Through the Trees 64 Time for a Drink 63 View from the Shore 68 The Wave 67 watery paint mixture, problems with 7, 20, 28, 30-1, 33, 37, 40, 53, 56, 58 wet-in-wet 10, 27, 31, 31 animals and birds 91, 93, 93 figures 87 landscapes 43, 57, 72, 73, 73, 82, 83 shadow 48 skies 32, 33, 35, 36-7, 36, 38, 38, 39, 39, 41 snow 49 soft reflections 26, 61, 62, 62, 63, 63, 91 stonework 80, 81 sunsets 35 trees 26, 55, 58 wet-on-dry animals and birds 91, 93 clouds 35, 39 crisp outlines 26, 35, 35, 44 figures 87 flowers 83 foregrounds 57, 57 hills and mountains 43, 44, 44, 47 rocks 68 shadows 48, 49, 55 skies 35, 35, 36 stonework 80 water and reflections 32, 61, 61, 62, 63, 65, 67, 71 winter 26, 26, 34, 48, 49, 51, 52,

54-5, 58, 58, 74

Evening Sky 36